Turner and Constable: Sketching from Nature

WORKS FROM THE TATE COLLECTION

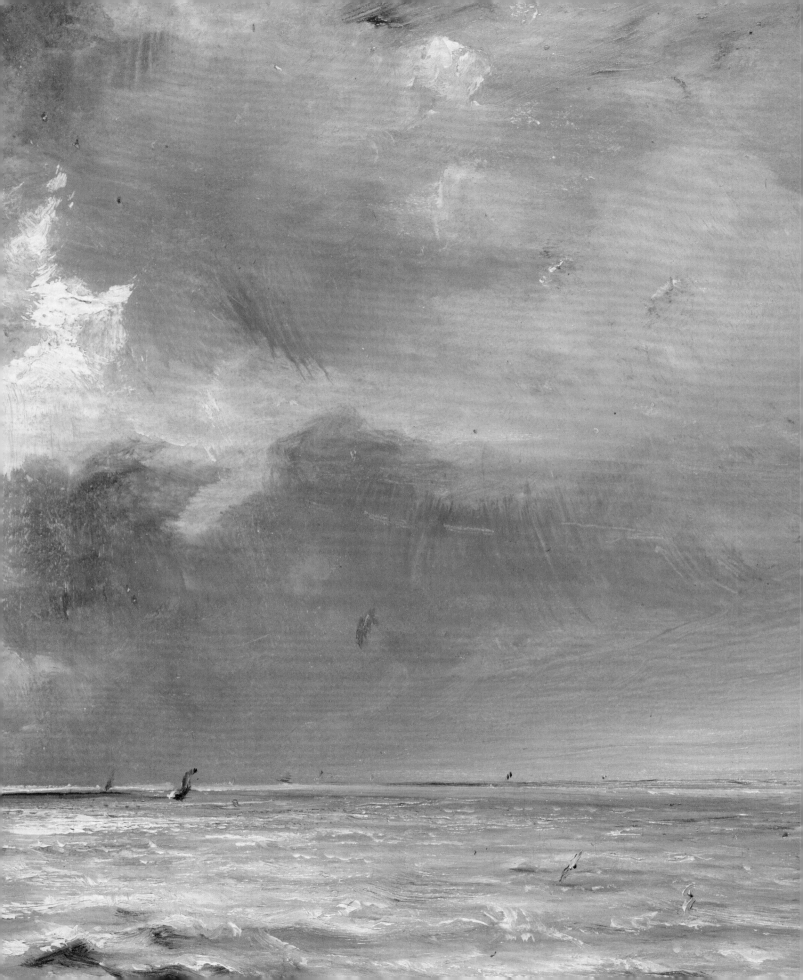

Turner and Constable: Sketching from Nature

WORKS FROM THE TATE COLLECTION

Michael Rosenthal
with Anne Lyles

Edited by Steven Parissien

TATE PUBLISHING

First published 2013 by order of the Tate Trustees
by Tate Publishing, a division of Tate Enterprises Ltd,
Millbank, London SW1P 4RG
www.tate.org.uk/publishing

on the occasion of the exhibition
Turner and Constable: Sketching from Nature
Works from the Tate Collection

Compton Verney
13 July – 22 September 2013

Turner Contemporary, Margate
8 October 2013 – 15 January 2014

Laing Art Gallery, Newcastle
1 March – 20 June 2014

A catalogue record for this book is available from the British Library

ISBN 978 1 84976 206 9

Distributed in the United States and Canada by ABRAMS, New York

Library of Congress Control Number applied for

Designed by Libanus Press Ltd
Colour reproduction by DL Imaging, London
Printed by Graphicom SPA, Italy
Photography © Tate Photography 2013 / Samuel Drake, Jo Fernandes and Mark Heathcote

Front cover (top): John Constable, *Harnham Ridge, Salisbury* 1820 or 1829 (detail of plate 22, p.70)
Front cover (bottom): J.M.W. Turner, *The Thames Near Walton Bridges* 1805 (detail of plate 35, p.87)
Frontispiece: John Constable, *The Sea near Brighton* 1826 (details of plate 20, p.66)

Measurements of artworks are given in centimetres, height before width.
Tate accession numbers are given in the caption to each work.

Contents

Foreword

This book explores the development, variety and innovation of the landscape oil sketch. This phenomenon first appeared in British art in the 1770s; flourished during the first two decades of the nineteenth century, pioneered by J.M.W. Turner and John Constable; and then effectively disappeared, save for Constable's persistence during the 1820s.

Taking oil paints into the countryside was something very new for British art. So were the ways in which Regency artists pursued this type of study. Some of the works profiled here were created over time, in the open; some were completed on the spot in one or two days, becoming finished paintings rather than sketches; and in other instances the painting done in the open air was later augmented by studio work. There are paintings (such as John Crome's *Mousehold Heath*, plate 55) which *look* naturalistic, but in fact are not, and which improve and enhance nature and industry to create a better aesthetic composition or to make a socio-political point.

By the 1810s, the widespread habit of painting in oil and watercolour from nature had led some British landscape painters to aspire to create a direct naturalism of a kind unprecedented in the history of British art, and actually antithetical to traditional academic conventions. The most important figure in this movement was Turner, who aimed to create landscapes that would be ranked alongside the more 'elevated' subjects of established fine art tradition.

This book, and the exhibition which originally accompanied it, initially arose from a conversation between Michael Rosenthal and Anne Lyles abut how this subject – expressed in so many beautiful and revealing sketches in Tate's collection – was ripe for re-investigation. Anne then talked to us at Compton Verney, and we decided to approach Tate, which, as part of its extensive loans programme, was delighted to work with us to ensure that these works were seen by as wide an audience as possible. The resulting exhibition is being held at Compton Verney between July and September 2013, and then travelling to Turner Contemporary at Margate and the Laing Art Gallery in Newcastle. Guest-curated by Michael Rosenthal, assisted by Anne Lyles, and internally curated by Steven Parissien, it is a splendid testimony to the creative collaboration of our eminent art historians and of the exhibition partners, and of course to the generosity and vision of Tate itself.

It has been, as always, a privilege and a delight to develop this project with Mike Rosenthal and Anne Lyles, and I would like to publicly thank both of them for their insight, assistance and good humour. Thanks, too, to my colleagues at Turner Contemporary and the Laing, Victoria Pomery and Julie Milne, with whom it has been a sheer pleasure to work. And I would like to express my gratitude for the enormous support and encouragement which Roger Thorp and his team at Tate Publishing have given us.

Particular thanks, though, must go to Caroline Collier, Director of Tate National, who has championed this project partnership from the very start. I must also thank Compton Verney's art team, led by Alison Cox and Penny Sexton, who helped to make this ground-breaking book and exhibition possible – and indeed all of Compton Verney's indefatigable staff, and who have made our relatively new gallery such a marvellous success.

Dr Steven Parissien
Director, Compton Verney

THE NATURE OF BRITISH LANDSCAPE PAINTING, c.1770–1830

Michael Rosenthal

This selection of works from Tate Britain focuses on a period during which landscape dominated British art. At its heart are the years 1792–1815, when the French Revolutionary and Napoleonic Wars closed the Continent to British tourists, and paintings of British scenery powerfully represented what would be lost were the French to triumph. In 1828 a scribe for the *Literary Chronicle* observed that:

> The English School of landscape painting has come to be of the first rank, and the contemporaries of Turner, Constable, Callcott, Thomson, Williams, Copley, Fielding, and others who we might name even with these masters, have no reason to reproach themselves with any neglect of their merits. The *truth* with which these artists have delineated the features of British landscape is, according to the general admission, unmatched by even the most splendid exertions of foreign schools in the same department.

This anonymous writer allowed the British school of landscape a pre-eminent position; albeit at precisely the moment it had been supplanted by subject pictures. He (I am assuming) stressed the '*truth*' with which its practitioners represented their subjects: presumably the accurate representation of what we might see, too, were we to be observing the actual landscapes that were their subjects rather than the fictional, dramatic effects, the invention of scenery or the staging of histories, all of which had been previously composed to sit within established pictorial traditions and conventions.

Although this is not really a tenable proposition – Turner's great *Dido Building Carthage* of 1815 (National Gallery, London) or Constable's *Leaping Horse* of 1825 (Royal Academy of Arts, London) are hardly literal representations of actual scenes – 'naturalistic landscape

painting' was, nevertheless, unusually prominent in the later eighteenth and early nineteenth centuries in Britain. Andrew Hemingway writes of its embracing 'types of painting both in oil and watercolour, which were understood as accurate representations of real places in their contemporary appearance, as if seen at particular times of day, in specific seasonal moments, in specific atmospheric conditions'; and significant numbers of these were at least partly painted from nature. Two of many examples would be George Lewis's oil sketch (one of twelve) and his more finished painting of a pastoral scene in Herefordshire (plates 52, 54), which he exhibited at the Society of Painters in Oil and Watercolours in 1816 and which he stated had been 'painted on the spot'.

The concern to highlight documentary verisimilitude that informs the paintings' titles – Lewis's *Hereford, Dynedor and the Malvern Hills, from the Haywood Lodge, Harvest Scene, Afternoon* is deliberately specific with regard to place and time of day – is evident in other respects, too. General coloration varies, befitting the different weather and lighting conditions. Although in two of the harvest scenes (plates 52, 54) we recognise the two trees to the left, they sit in a different relation to one another because the sketch was painted from a position leftward of the viewpoint in the larger work, and from closer in. Lewis's harvesters are individuals (and improbably clean ones at that), not generic labourers.

In 1813 Lewis had gone sketching in Wales with John Linnell, another practitioner of 'naturalistic landscape' whose earlier, ambitiously large *Kensington Gravel Pits* (fig.1), which also had a radical connection with oil sketches done on the motif, exhibits comparable pictorial concerns. Such sketches first appeared in British art in the mid- to later eighteenth century: the works of Thomas Jones (plates 2, 3, 5, 6, 23) are significant examples. And from the 1790s

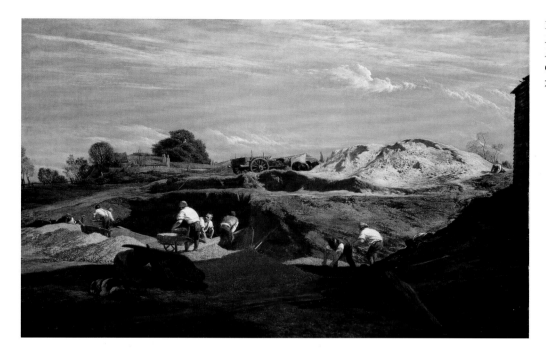

Fig.1 John Linnell
Kensington Gravel Pits 1811–12
Oil on canvas
71.1 × 106.7 N05776

oil sketching became significant for a number of painters, flourishing during the 1800s and 1810s. The practice had always followed formal protocols, and the 'free-standing' oil sketch has to be distinguished from those done, as some of Constable's were, as stages in a sequence that culminated with the creation of a rather more portentous oil painting.

Oil sketching from nature is so impractical as to be perverse. Lawrence Gowing observed that the 'normal and natural way to capture nature for art was by drawing. Oil paint was an elaborate technique for the studio; the empirical media were crayon and pen.' Indeed, artists such as Jones used oil and graphic media equally: while in Naples, on 28 December 1782, Jones wrote of beginning 'several studies of the different Scenes & Objects seen from the Windows' of his new premises, 'some of which were painted in Oil, & some in Water Colors.' Such watercolours remind us that the concern with painting nature directly was general. As Anne Lyles shows (p.30), Thomas Girtin's example (fig.2) was exceptionally influential. Oil paint presented real problems: metallic tubes of oil paint were not available until the 1840s; before then artists used bladders containing the medium, or simply pre-set their palettes. The number of brushes you could comfortably hold at any one time was restricted, while painters had to cart their kit with them, and cope variously with wind, animals and insects, and the complex business of getting paint onto the chosen support.

Painting from nature was inherently difficult. It was essential to compensate for light reflecting off the paint surface and completely distorting tonal values. As the watercolourist Jonathan Skelton wrote from Rome in July 1758:

> I intend to paint with a body in Water colours [gouache] after Nature; as they do not shine in on the picture, it will therefore be as easy painting without doors as within: which will make the study more commodious than that of painting in oil colours, for in the open Day-light they shine so much when they are wet that there is no such thing as seeing what one does.

Sir George Beaumont's *Landscape* (plate 8), perhaps a scene in North Wales, was evidently painted rapidly on to paper – the support traditionally preferred for oil sketching. The sketch was on a small scale, chromatically restricted – an

Fig.2 Thomas Girtin
*The White House
at Chelsea* 1800
Watercolour on paper
29.8 × 51.4 N04728

aid to the speedy work that painting from nature demanded – and probably pinned to a board. Although foreground detail can just be made out, that area is strikingly dark – one of the consequences of painting in daylight. (Sunlight distorts tonal perception.)

Working in oil paint before the subject was, traditionally, best done indoors and from a window, or at the very least under a parasol. Around 1777, the watercolourist Thomas Hearne pictured Beaumont, together with the landscape painter and diarist Joseph Farington, doing precisely this before a waterfall in the Lake District. That so many artists did paint in oil from nature suggests that they were prepared to suffer those real practical inconveniences to get the great range of effects, textures and chromatic variety obtainable with oil but not watercolour paints. Cumulatively, these works represent an extraordinary moment in European landscape painting.

*

For many years British art was deemed unworthy of study. John Baskett recalls the subject area being regarded with 'indifference, almost approaching hostility'. And then, from 1959 onwards, the American collector Paul Mellon, advised by Basil Taylor (the one British expert with the *nous* and foresight to see quite what a goldmine was awaiting excavation) began to buy British. In 1963 Mellon exhibited some 451 works from his rapidly-accumulating collection at the Virginia Museum of Fine Arts, and in 1964 the show travelled to the Royal Academy in London. British scholars and curators started paying attention to what, until recently, had been on their own doorstep. Of course, British art was already evident in national collections. There was the Turner Bequest. Paintings such as the two Lewis scenes of Herefordshire (plates 53–4) had been presented to the Tate. However, only from the later 1960s did collectors begin to buy British art systematically, and even then often because of the interests and drive of *individual* curators – notably, in the early days, Leslie Parris, who joined the Tate as an assistant keeper in 1964. In 1969 John Gage curated a ground-breaking exhibition, *A Decade of English Naturalism 1810–1820*, which jolted people into discovering that not just Constable (whose oil sketches had, until then, been lazily seen as Impressionistic *avant la lettre*), but Peter De Wint, J.M.W. Turner, George Garrard, John Linnell, David Cox and others had been painting oil sketches and watercolours on the motif at (and before) that period. From then on there was real intellectual and curatorial activity, not just with regard to oil sketches, but to British land-

scape painting more generally. Parris and Conal Shields mounted the small but ground-breaking exhibition *Constable the Art of Nature* at the Tate in 1971, following it with the great *Landscape in Britain 1750–1850* (the catalogue to which *still* offers the best overview of its subject), held at the Tatein 1973. In 1972 John Barrell's book *The Idea of Landscape and the Sense of Place 1730–1840: An Approach to the Poetry of John Clare* proved a ground-breaking and historically unimpeachable study of painting and literature in tandem.

1975 and 1976 saw major Turner and Constable retrospectives at the Tate. In 1979 Philip Conisbee published a canonical article on the history of the practice of oil sketching, and in the 1980s major books were published on British landscape painting by Ann Bermingham, Ronald Paulson and others (including John Barrell, again), while important exhibitions of British landscape painting from Yale and of the art of Richard Wilson were curated by Louis Hawes and David Solkin respectively. However, after the exhibition *Richard Wilson: the Landscape of Reaction* in 1982, the momentum subsided. The catalogue to the latter, which suggested that beauty lay in the eye of the beholder, and that the peace and tranquility seen in Wilson's British landscapes might not have been perceived in quite those terms by the lower orders of his period, provoked a worryingly extreme reaction, some commentators barking that if the Tate was going to publish such Marxist claptrap it must be subjected to censorial supervision. Endemic hostility to disinterested scholarship, during a period when British politics took a turn inimical to the engaged study of the humanities and many scholars were beginning to rush up the blind alley that was Postmodernism, may have attributed to landscape painting's loss of universal appeal. There were important monographs on the subject by Ann Bermingham, Stephen Daniels, Andrew Hemingway, Charlotte Klonk, Dian Kriz, Kim Sloan and others, and exhibitions, notably that on Thomas Jones in 2003 and the wonderful *Constable: the Great Landscapes*, curated by Anne Lyles for Tate Britain in 2006. But the general impetus that had driven landscape studies had subsided.

However, British landscape painting is not, now, of any less moment than it was for Parris, Gage and the others in the 1960s and '70s. The selection of works made in this book demonstrates how valid and profoundly interesting the subject remains today. The selection cannot be comprehensive, for no collection can have universal coverage: David Cox painted some stunning oil sketches, but those in the Tate are from the 1850s, beyond the chronological limits of this study, so he is unrepresented. Women were a hugely significant constituency when it came to creating or viewing landscapes – looking back in 1833, one writer noted how 'the excellence which this art has attained is in no small degree to their good taste' – but they, too, are absent. Sir George Beaumont (plate 8), the Warwickshire Clergyman the Reverend William Bree (plate 31) and William George Jennings (plate 21) represent the many talented amateurs who practised landscape painting more generally. The works illustrated here, as selective as in any exhibition, dictate its curatorial narrative. A brief survey of the history of the pan-European phenomenon of painting landscapes in oils from nature will serve to introduce a more focused account of British oil studies from nature and 'naturalistic' landscape.

*

Plein-air (open air) oil painting developed in Rome during the seventeenth century. The German history painter Joachim von Sandrart wrote how the great French landscapist Claude Lorrain was struck by how he (Sandrart) 'painted many works from nature itself' and how 'this pleased him so much that he applied himself eagerly to adopting the same method.' Sandrart explained that by painting only the middle distance and background, he could avoid pictorial clutter and represent nature in a general kind of way – a practice which persisted into the nineteenth century, when Corot, accosted by someone who claimed not to be able to recognise what he was painting, pointed to a scene at some distance from where they stood. Claude himself is reported to have painted from nature, and the idea that this was the only way to capture both forms and colours with any degree of accuracy soon

became axiomatic. By the eighteenth century the practice was spreading rapidly, particularly amongst French painters in Rome. Climate helped: in Italy you could rely on stable light conditions, while the weather was conducive to working out of doors.

In the middle of the seventeenth century Richard Symonds, an Englishman painting in Italy, had a special box made for him which included discrete sections for his paints, brushes, oils and painting equipment. The palette was pre-set and stabilised in the box by pegs; Symonds then stretched his canvas across the lid of the box and, presumably sat with all this paraphernalia on his knees. Philip Conisbee supposed that such boxes were widely used, noting that Alexander Cozens was using one in 1746. In 1802 the Scottish artist Andrew Robertson thought that if he were 'to study landscape … I would finish in the field. I would have a box for that purpose', while in January 1825 John Constable wrote to his friend Archdeacon John Fisher of Salisbury that he had sent him a package in which were 'a dozen of my Brighton oil sketches – perhaps the sight of the sea may cheer Mrs F – they were done in the lid of my box on my knees as usual.' (plate 20)

In 1749 Claude-François Desportes, son of the artist François Desportes, spoke of how his father believed that only painting in oil *en plein air* allowed the artist to capture the actualities of colour accurately, and that his father had favoured a strong paper which absorbed the oil paint and allowed him to add to the work without having to wait for the paint to dry. The writer Roger de Piles may have been referring to Desportes in his *Cours de Peinture* of 1708 in noting how some artists had

> designed after Nature in the open fields, and have there quite finished those parts, which they had chosen, but without adding any colour to them. Others have drawn, in oil colours, in a middle tint, on strong paper; and found this method convenient because, the colours sinking, they could put colour on colour, tho' different from each other. For this purpose they took with them a flat box, which commodiously held their palette, pencils, oil, and colours.

After 1765, when he had returned from Rome to Paris, the French landscapist Claude-Joseph Vernet committed his thoughts to paper in a 'Letter on landscape painting'. He had come to the conclusion that the 'shortest and surest method is to paint and draw from nature. Above all you must paint, because you have drawing and colour at the same time.' A subsequent major contribution to the expanding literature on painting *en plein air* was the *Elémens de perspective pratique à l'usage des artistes*, published in 1800 by the French artist Pierre-Henri de Valenciennes (whose Italian oil sketches were contemporary with those of Thomas Jones). Valenciennes, who had been both encouraged to paint in the open and given practical advice by Vernet, was summarising an accumulated wisdom. He observed how certain artists would work on the motif for two hours only, and return on subsequent days at the same time. Constable worked out-of-doors on *Boat Building* (Victoria and Albert Museum, London) at a specific time during the later afternoons of September and October 1814, although he was lucky. Valenciennes wrote of how many artists had left their studies unfinished because 'they were unable to recapture the same natural effects', and advised the painter to begin with the sky, which would set the overall tone of the work, and then to concentrate on the middle ground.

French artists in Rome were laying the foundations of what soon became international practice. Moreover, painting *en plein air* was an exercise which evolved formal conventions and particular ways of applying paint. There were, for example, distinct similarities between the techniques of Jones and Valenciennes. And by the 1830s, the *plein-air* paintings of artists of the Düsseldorf School such as Eugene von Guérard and Johann Wilhelm Schirmer also shared a similar pictorial vocabulary. Vernet or Valenciennes never meant that the oil sketch from nature should be seen as anything more than a preliminary stage in the creation of a landscape that would sit very firmly within the tradition of high art. The sketch, painted on the spot, would become, through studio re-workings, a building-block for a work that communicated elevated ideals of both nature and humanity – albeit one which grounded

those fictions in observed realities. 'A sketch', John Constable wrote to his friend John Fisher in November 1823, 'will not serve more than one state of mind & will not serve to drink at again & again.' Indeed, the oil sketch from natuure had its fixed place in academic theory: the initial stage of development. Despite being a lowly genre, however, it was believed that landscape painting should still concern itself with elevating the mind, best achieved by representing some notable history in an idealised way. And it should always originate from particular nature, the *étude*, painted at the subject; from this study would be developed *ésquisses*, studio-painted compositional studies, and *ébauches*, lay-ins for the composition itself. All was organised in a system of rank and order.

British artists learned about oil sketching from nature in mid-eighteenth-century Rome from Claude-Joseph Vernet – who, along with Richard Wilson and Alexander Cozens, lodged at the Palazzo Zuccari in Rome. Here he turned Wilson from portrait to landscape, as demonstrated by *plein-air* works such as *The Palace of Mycenas, Tivoli and Distant View of Rome* of 1752 (National Gallery of Ireland, Dublin), which shows an artist painting on a reasonably-sized canvas on an easel. Sir Joshua Reynolds reportedly advised the marine artist Nicholas Pocock:

> above all things to paint from Nature instead of drawing; to carry your palette and pencils to the Waterside. This was the practice of Vernet, whom I knew at Rome. He showed me his studies in colours, which struck me very much for the truth which those works have which are produced while the impression is warm from Nature …

Wilson's pupils Thomas Jones and William Hodges certainly painted in oil from nature. Sir George Beaumont and Joseph Farington had been taught by Cozens and Wilson respectively, and both were mentors to the young John Constable. There was thus an historical continuum linking Wilson, through his pupils, to younger artists.

On the morning of 29 May 1802, Constable paid Beaumont a visit, then went home and wrote a now-famous letter to his friend John Dunthorne, the East Bergholt

plumber and atheist – now best known for the stirring words: 'there is room enough for a natural painture'. Beaumont had evidently inspired Constable with the ambition to become an original and morally exemplary landscape ainter. He had, Constable wrote, 'been running after pictures and seeking the truth at second hand', although he had at least not 'endeavoured to make my performances look as if really *executed* by other men'. He was painting nature at as it appeared in art, not actuality, though he *had* avoided pastiche. The proper course, Beaumont had advised, was to 'make some laborious studies from nature – and … endeavour to get a pure and unaffected representation of the scenes that many employ me' as an alternative to the 'great vice of the present day … *bravura*, an attempt at something beyond the truth' for '*Truth* (in all things) only will last and can have just claims on posterity.' A generation earlier, Sir Joshua Reynolds was 'struck … very much for the truth' of Vernet's sketches; now Constable was earnestly aiming for truth in his own landscapes.

Dr Johnson had offered various definitions of the word 'truth' in his *Dictionary* of 1755: the term meant was 'contrary to falsehood', he declared, and corresponded to honesty and virtue. Thus a truthful landscape was, for Constable, an inherently moral one. In 1793 the artist William Marshall Craig published *An Essay on the Study of Nature in Drawing Landscape*. Craig censured the way that 'a certain set of signs has been employed, as by agreement, to represent, or signify, certain objects in nature, to which they have no resemblance', thus divorcing imagery from actuality and destroying its integrity. Instead, Craig advised the student of art 'to imitate Nature exactly'.

Studying the 'truth' of nature at first-hand, free from any fictitious embellishment, meant that the spectator of the work was expected to take its representation at face value. This was not unproblematic, because landscapes clearly grounded in the observation of actualities were not necessarily always as spontaneous or uncalculated as their composition suggested. William Delamotte's *Waterperry, Oxfordshire* (plate 47) is nothing if not naturalistic, and executed on a piece of board small enough to be practicable for painting from nature. An inscription on the

work's back confirms that it was painted over two days. Surfaces were worked up, and the flowers to the left painted wet onto dry. Thus it was a landscape done over time, a completed painting rather than a study. And despite the unexceptional ordinariness of this view of a village street with fences, gates and houses, Delamotte's girl with the earthenware pitcher cannot but bring Thomas Gainsborough's *Cottage Girl, with Dog and Broken Pitcher* (1785, National Gallery of Ireland, Dublin) to mind. (The girl, faceless though she is, is as undramatically natural an inhabitant of Waterperry as the hens on the other side of the rutted track, while the village is rendered in the familiar dull hues of an English landscape under the muted light of a cloudy summer's sky.) The 'natural' in painting is not contingent always on the work's being painted in front of nature. It is worth bearing this lack of straightforwardness in mind as we make a survey of various sketches, studies, and paintings from nature – which, since it is chronological, must begin with the Tate's George Stubbs's *Newmarket Heath, with a Rubbing-Down House* of *circa* 1765 (plate 1).

*

Stubbs was a sophisticated and learned artist, with academic aspirations. He knew those various compositional *schemata* of seventeenth-century origin, frequently referred to by British landscape painters of both the eighteenth and nineteenth centuries. One such method, developed by Claude Lorrain and seen later in Turner's *Apullia in Search of Appullus* (fig.3), framed the landscape with a *repoussoir* of trees and accented the middle distance with a bridge. Another approach, perfected by seventeenth-century Dutch landscapists, used a natural feature – in Stubbs's *Reapers* (fig.4) it is a line of trees – to drive a wedge into the distance. The idea was to reinforce perspective, the linear order perceptually imposed on nature by the creative intelligence of the artist. Yet in his studies of the Rubbing-Down Houses of Newmarket, Stubbs eschews compositional devices, does not line up buildings and stays true to the treeless facts of the terrain. The chromatic monotony, general plainness and lack of organisation encourage the conclusion that the work was executed with very close reference to its subject. Paint surfaces are too built up to be compatible with *plein-air* painting, but Stubbs may well have made drawings or watercolours as he anatomised the terrain in a similar way to his dissections and systematic drawings of equine cadavers.

The subject of painting from nature is bafflingly complex. Appearances can be deceptive: for example, Alexander Cozens's undatable *Wooded Coast Scene* (plate 4) looks as though it could have been painted outside – there is a limited palette comparable to that in Sir George Beaumont's equivalent landscape (plate 8), and forms are not detailed, all of which would fit with rapid work outdoors – but in truth this probably was a formal study of an imagined landscape painted in the studio. Cozens was keen on encouraging creative invention. His famous system of 'blotting', in which artful marks on paper would suggest landscape compositions to the inventive artist, was symptomatic of this imaginative attitude. This tendency to imagine landscapes extended to penciled outlines (fig.5), which were sequentially filled in until they culminated in landscapes such as the *Wooded Coast Scene*. Cozens knew both Vernet and Wilson personally, and his watercolours of scenes in and around Rome suggest an awareness of the importance that painting from nature was then assuming both for French painters in Rome and those who came within their orbit – which, since Rome was a small town, must have been many other artists.

It was left to Wilson's pupils, William Hodges and Thomas Jones, to paint spectacularly from nature in oil. Hodges created some extraordinary works in extraordinary circumstances while voyaging with Cook on his second Pacific expedition of 1772–5, rendering precisely an almost-vertical sun obliterating chiaroscuro and flattening surfaces – a phenomenon as unfamiliar to any European as the previously-unknown *flora* of the volcanic islands amongst which they were sailing. Here art was so tied to material reality as to become effectively scientific observation, a facet of oil sketching that was to remain highly significant. When Constable reportedly concluded the last of the lectures he delivered at the Royal Institution in 1836 by

Fig.3 J.M.W. Turner *Apullia in Search of Appullus* exh. 1814
Oil on canvas 148.5 × 241 N00495

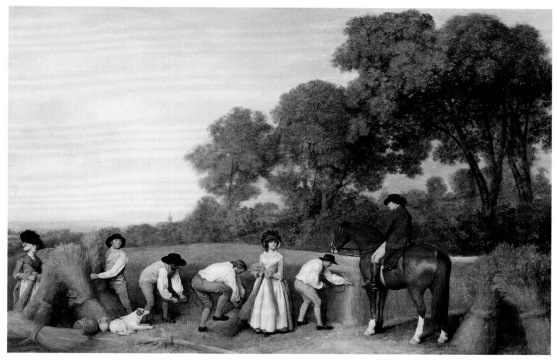

Fig.4 George Stubbs *Reapers* 1785
Oil on wood 89.9 × 136.8 T02257

Fig.5 Alexander Cozens *A Wooded Hill Top
with Thunder Clouds* date not known
Graphite and watercolour on paper 22 × 31.1 T08062

stating that painting was 'a science, and should be pursued as an inquiry into the laws of nature' he was telling his audience nothing new.

In August 1776 Thomas Jones wrote of having completed 'a number of Studies in Oil on thick primed paper – after Nature' at the family house of Pencerrig, near Builth Wells in Wales (plate 3). The dark tonality indicates that Jones had yet completely to overcome the problems of adjusting his colouring when painting in daylight, although he does manage to depict scattered sunlight penetrating the semi-overcast sky as well as achieving chromatic matches to the harvested cornfields and ploughed ground. Jones painted the horizontal landscape with the sun behind him and to his right, and although struggling with the *chiaroscuro* in the mid-ground managed the effect of light on distant hills beautifully. It was, however, in Rome and (in particular) in Naples in the early 1780s that Jones created those extraordinary studies from nature for which he has become best known. The presence in Rome of other European artists working in the same way, and talking to one another, must have contributed to that development. It was no coincidence that Valenciennes reached Rome in 1778, a couple of years after Jones.

Thomas Jones often mentioned sketching in watercolour and oil during his Italian years. These works are variously fascinating, not least for tending to concentrate on landscape rather than, as was more conventional, the monuments of antiquity. When Francis Towne (plate 45) arrived in Rome in March 1781, Jones both showed him 'all the Curiosities of Art and Nature in, and about this delightful City' but was also 'able to conduct him to many picturesque Scenes of my own discovery.' Although Jones's sketches informed Claudean finished landscapes such as *Lake Albano – Sunset* (Yale Center for British Art) of 1777 (purchased by Frederick Hervey, the Bishop of Derry and subsequently fourth Earl of Bristol, who was then on his Grand Tour), they tend more generally to be apparently unmediated pictures of record. In *The Bay of Naples and the Mole Lighthouse* (plate 6) the lighthouse to the left is a pictorially useful vertical accent; yet the patterning of the sails, partially rhyming with the patches of light on the distant hills seems almost random in a sketch as much about atmosphere and space themselves. *Naples: Buildings on a Cliff Top* (plate 5) fills most of the paper with the cliff, realised as creamy slabs and covered with vegetation. The window of the building to the right is sliced by the paper's edge, giving the impression that Jones had aimed at creating a snapshot of a scene which is mostly about colour, patterns and shape. This view was some way from the landscape of intellectual order expected from the academic painter. However, Jones's surfaces are far more worked than those of *The Bay of Naples and the Mole Lighthouse*, suggesting either that, as Valenciennes had once proposed, he had returned to paint the motif at a particular hour on successive days, or that he had worked on the landscape in the studio as well – which we know was his practice. On 27 November 1780 Jones recorded how the 'Rain drove us home about two in the Afternoon and it continued wet the rest of the Day which kept me employ'd in touching on the Sketches I had made'. Jones thus made sketches out-of-doors and worked further on some of them in the studio. It would appear from his *Mount Vesuvius from Torre dell'Annunziata near Naples* of late July 1783 (fig.6) that Jones had, late in his Italian sojourn (he sailed for England on 3 August), taken the logical step of beginning to paint composed landscapes with an even closer reference to nature. The features characteristic of the

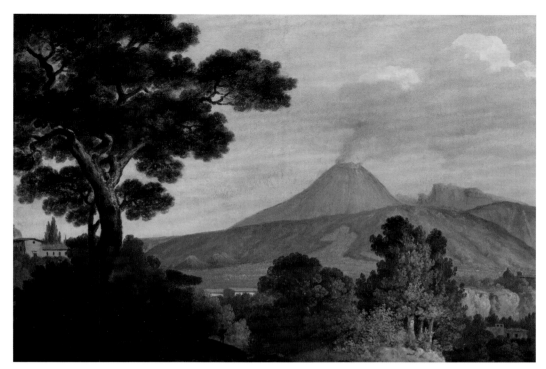

Fig.6 Thomas Jones
*Mount Vesuvius from
Torre dell'Annunziata
near Naples* 1783
Oil on paper laid on
canvas 38.1 × 55.2
T01844

naturalistic sketch – a lack of compositional organisation, a tendency to focus on a middle distance, and colouristic conservatism – are missing here. The large tree to the left serves as a Claudean *repoussoir* – an object used to create an illusion of depth – while simultaneously counterbalancing the smoking Vesuvius in the distance. Jones introduces *staffage* – an incidental figure, in this case in the form of a standing man – left of centre, holding a rifle or staff. The surfaces of foliage are worked and differentiated according to mass and colour.

It appears very much that Jones had, for a brief moment, taken his naturalistic landscape to the level perhaps presaged in Joseph Wright's melodramatic *A View of Catania with Mount Etna in the Distance* of around 1775 (fig.7). Jones's almost-invisible figure is the only aspect of *Mount Vesuvius from Torre dell'Annunziata* which suggests that it is anything more than the documentary record of topographical data of the kind also being created in watercolour by his friend and painting companion Giovanni Battista Lusieri.

Two issues are raised here. There is the practical, procedural one: we need to distinguish between oil sketches executed directly from nature and those more ambitious landscapes that were touched up afterwards. We must also attempt to discern what the consequences of these variations in practice were.

*

In certain cases it is relatively easy to be sure that a landscape sketch was done in the open, 'before the motif'. One such is George Garrard's 1791 *Coombe Hill* (plate 7). It is painted on card, and is relatively small, suggesting it was painted outside. Moreover, Garrard has used a limited palette of dilute paint which he has worked rapidly, painting wet-in-wet when the foliage meets the sky. Using a comparatively wide brush in areas such as the foreground, he eschews detail, and there are passages which do not resolve figuratively (for instance, immediately to the right of the tree). William Henry Hunt's *Study from Nature* (plate 33) likewise had to have been done *en plein air*, in this

Fig.7 Joseph
Wright of Derby
*A View of Catania
with Mount Etna in
the Distance* c.1775
Oil on canvas
66 × 88.6 T01278

instance on the Thames. Interestingly, Valenciennes had recommended tree trunks as promising subjects for the outdoor oil-sketcher. Such apparently unpropitious subjects were also recommended by the Scots artist Andrew Robertson (a friend of Constable's), who wrote in 1802:

> Often what is least picturesque to the eye, becomes full of character when on paper. Draw and copy the colouring of rocks, stumps, foreground, plants, etc. and when you introduce them in landscape, you will be astonished at the originality of them.

Hunt was doing precisely this, and we shall see how this was a significant element of others' practice, too.

The elongated vertical of a landscape that does not extend to the bottom of the board on which it is painted is not often found in more formal work. Hunt, like Garrard, restricted his palette, and knew (as de Piles had known) that oil paint would sink into the support so he could paint over it – as in the detailing of the leaves. In the way of early Gainsborough portraits, Hunt uses the board itself to supply a pictorially-unifying mid-tone. It is less easy to be categorical with such a work as Peter De Wint's *River Scene at Sunset* (plate 40). De Wint made oil sketches when accompanying John Raphael Smith, the artist to whom he was apprenticed, on fishing trips along the Thames, and painted this work on one or more of these excursions, for the sky and distant hills had to have time to dry (De Wint's technique of painting directly onto board facilitated this), after which he struck in the trees' foliage with strikingly staccato brushwork, and worked their almost abstracted reflections in the water. De Wint's resulting depiction of the sun is as impasted as in any of Turner's renderings of that star.

Among other things, De Wint was particularly concerned with atmospheric effects. These preoccupied others, too, as is evidenced by the astonishing watercolours by Cornelius Varley and Joshua Cristall (plates 9 and 10). The latter almost perversely ignores the sublimity of the Welsh

scenery in order to capture mountain forms dissolving in the gloaming. The contrast with De Wint's oil study demonstrates precisely why artists were willing to battle with oil paint in order to achieve far more complex *simulacra* of comparable effects. To do this successfully demanded hard work, in order to acquire the necessary dexterity and skill – a process manifested in the artistic development of John Constable.

Constable began painting oil sketches from nature in 1808. Those few that survive are tentative, the paint laid in the broad masses – as in the view of Epsom of 1809 (plate 14) that he painted on to board during a visit to his cousins, the Gubbinses, who lived there. While he still tended to wash the oil paint onto its support in the manner of watercolour, he had begun to exploit the peculiar capabilities of the oil medium. Constable was, as is clearly evident in the sky, gaining the confidence to use the suggestive brushwork and chromatic variation which is seen to spectacular effect in his later *Dedham from Gun Hill, Langham* (plate 17).

The Dedham landscape may date to 1810 or 1815. It displays unprecedented dexterity and accuracy of touch – so much so that it may be a studio work. However, we know from such sketches as that of the sun rising over East Bergholt Rectory of 1810 (John G. Johnson collection, Philadelphia) that Constable had attained quite exceptional technical virtuosity, and thus that this view down from Langham to Dedham and beyond to the Stour estuary could as plausibly have been painted out of doors. He used the ground to contribute to the effect of the clear areas of the sky, filling in masses with local colour. In the case of the trees that cascade down from the right, he dabbed paint on to larger patches of darker colour to get the effects of light. However, Constable could not achieve a comparable naturalism in his exhibition works, painted in the studio from multiple sketches done out-of-doors. In a letter of February 1814 he wrote to John Dunthorne of his problems marrying the general with the particular, and of his landscapes having too wintry a look. He saw the solution in 'finishing of my studies more in future', and declared how he was 'determined to finish a small picture on the spot for every one I intend to make in future', something he had spoken about but not got round to doing. A small finished picture would serve as a model for the studio work.

Here Constable was breaking with the academic practice he had previously observed in working up his *études* in the studio, and was heading in a radical direction. Traditional academic theory maintained that the nature represented in a landscape painting had to be the distillation of repeated observation if it was not to be limited to one time and place. Constable's new idea that landscapes faithfully representing the detailed particularities of actual places could aspire to high artistic status was a revolutionary denial of this tradition. Logic probably suggested that he simply paint directly from nature. He began in mid-September to mid-October 1814, painting on a *View of Dedham* (Museum of Fine Arts, Boston) during the early mornings and *Boat Building* (Victoria and Albert Museum, London) in the afternoon. For the one he could keep painting equipment in the family house, only four hundred metres from the site where he set up the easel; for the other, he worked at Flatford Mill, which is where the local river barges were built. Although he did paint an oil sketch for the *View of Dedham* (Leeds Art Gallery), all the other surviving preparatory work for each picture was executed in *pencil*. His landscapes were as premeditated and thought out as earlier works, but were now painted in the open.

Constable continued painting finished works from nature until his marriage and his subsequent exile from Suffolk. The small *Brightwell Church and Village* (plate 50) was commissioned by a Reverend F.H. Barnwell in 1815. Constable documented what he saw: from the poppies in the nearby field to the excavations in the distant, left-hand one. We can get an idea of his techniques for achieving these effects from the *Fen Lane, East Bergholt* (fig.8), which he painted onto a kit-kat portrait canvas (a half-length portrait which includes the hands) probably in 1817, when he and his wife Maria spent what was for him a last long trip to Suffolk. His *plein-air* technique developed from that of his oil sketches: he blocked in colouristic and tonal areas to establish the substructure of the landscape before

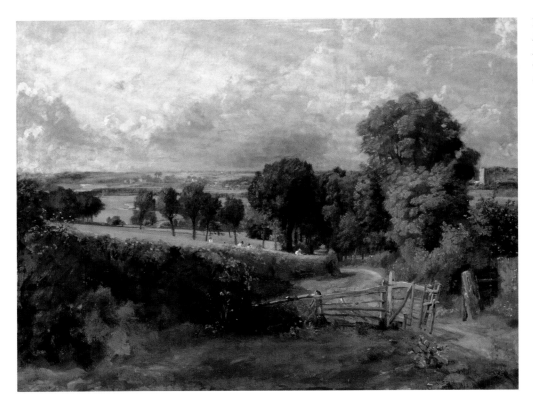

Fig.8 John Constable
Fen Lane, East Bergholt ?1817
Oil on canvas
69.2 × 92.5 T07822

using finer brushes to build up detail, as with the gate or the elms to the right.

Constable was not alone in turning to naturalistic art. He was, however, apart from that loose grouping of artists with whom we principally associated the practice of sketching in oil from nature. David Blayney Brown has made a case for J.M.W Turner to have been encouraged to paint from nature by William Delamotte, whom he knew well enough to visit at Oxford in 1800. Delamotte was also friendly with the Reading painter William Havell, who painted oil sketches of great accomplishment (fig.9) along the Thames in the mid-1800s (coincidentally at the same time as Turner).

William Henry Hunt and John Linnell were both taught by John Varley. As Anne Lyles demonstrates, significant oil sketchers such as these were evolving from a *watercolour* tradition. Linnell's biographer, Alfred T. Story, writes how:

> Varley's motto was 'Go to Nature for everything', and henceforth Linnell adopted it as his own. In order the better to enable his pupils to carry out his advice, Varley in the summer took a house at Twickenham near to the river, and sent them out into the highways and byways to make such transcripts as they could.

Linnell's sketch of the Thames with an eel trap (plate 32) was, like Hunt's *Twickenham* (plate 33), painted on one of these river excursions in 1806. Story writes how, 'During the summer at Twickenham, Linnell spent a great deal of time with Hunt – on the river and in the neighbouring lanes and fields – sketching and painting, using oils and working on millboard.' David Cox and Peter De Wint entered Varley's orbit after they arrived in London respectively in 1804 and 1806. By 1809, when they were all living at Kensington Gravel Pit (the area around the modern Notting Hill Gate), David Blayney Brown has noted that Augustus Wall Callcott came to know William Mulready and John Linnell 'very well'.

The naturalistic landscape painted by these artists raises serious historical issues. Andrew Hemingway has put a

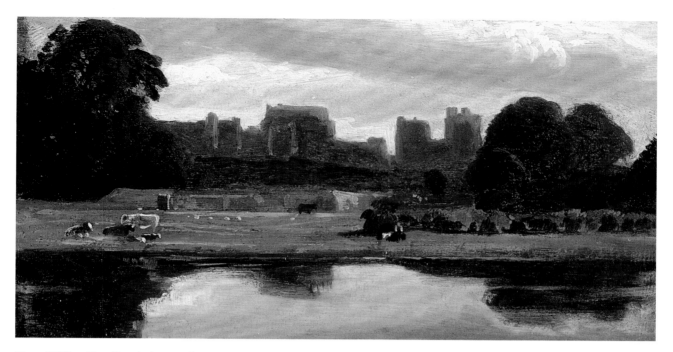

Fig.9 William Havell *Windsor Castle* c.1807
Oil on card 11.7 × 21.9 T03394

persuasive case for the Thames paintings that Turner exhibited over the years 1805–12 having 'represented a major example, both thematically and formally, for those who saw their project as to produce a distinctly British type of landscape painting.' Turner's 'project', however, was, arguably, a very different kind from that of Linnell or Lewis. Turner leased Sion Ferry House on the Thames at Isleworth in late 1804, and maintained a base of some kind on the river until 1826. Consequently, from the mid-1800s he began painting and sketching on the Thames and its surrounds. Turner sketched in oil only exceptionally, and, when he did, used these sketches in his own way. Certainly *Walton Reach* and *The Thames Near Walton Bridges* (plates 34–5), which are fairly small, can be matched with comparable works such as De Wint's *River Scene at Sunset* (plate 40) or, for that matter, some of the oil sketches Constable painted on the Stour at Flatford around 1810 (fig.10). Turner painted deftly in a wide range of colours onto a wood support, and Conal Shields has 'tentatively' suggested that the artist might have used the *camera lucida* that William

Wollaston patented in 1807, which projected an image of a subject on to a surface by means of a prism, placed above that surface, and thus gave the artist something exact to copy. Though this theory cannot be proven, it does serve to remind us that landscape painters would occasionally resort to optical aids – and even invent them, as Cornelius Varley did in 1811 with his Graphic Telescope.

As David Blayney Brown and others have pointed out, Turner's river 'sketches' served as foundations upon which a finished and composed landscape could be built. *Godalming from the South* (plate 13), another small work on mahogany veneer, blocks in the shapes and dominant colour masses of the landscape, the River Wey snaking into the distance, intermittently visible. It seems as though Turner used perhaps a brush handle randomly to hatch areas in the foreground: a small brush loaded with dark paint has outlined parts of a fairly free representation of the church of St Peter and St Paul. Moreover, he selected a viewpoint that allows the parts of the landscape to be composed in a manner which compares interestingly with

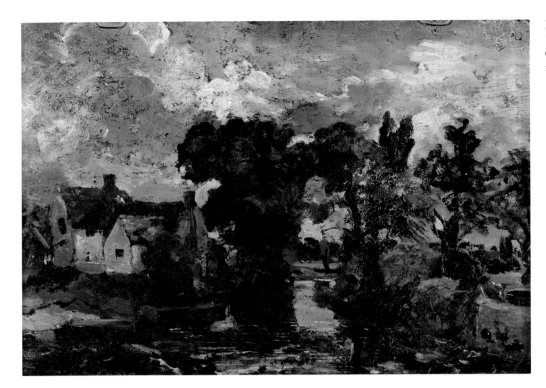

Fig.10 John Constable
The Mill Stream c.1810
Oil on board 21 × 29.2
N01816

Constable's *Dedham from Gun Hill*. Turner's view travels through a woody gap down to a valley in which a church is prominent before terminating in hills (in Turner's case) or in the ocean (in Constable's). This technique relates each landscape to an iconic prototype: Claude Lorrain's *Landscape with Hagar and the Angel* (1646, National Gallery, London), then the prize possession of Turner's arch-enemy, Sir George Beaumont. Turner would himself refer pictorially to this elevated prototype in his *Crossing the Brook* (fig.11), exhibited at the Royal Academy in 1815.

Turner's approach elevated each oil sketch above a simple record of particular appearance by setting them within a tradition of idealised landscape. Claude, according to Sir Joshua Reynolds, 'was convinced that taking nature as he found it seldom produced beauty. His pictures are compositions of the various draughts which he had previously made from various beautiful scenes and prospects.' In consequence, Reynolds held, Claude's works conducted us 'to the tranquility of Arcadian scenes and fairy land.' By 1815, Turner and Constable were effectively suggesting

that the British landscape might be wrought into an equivalent of the culturally-laden and highly idealised works of Claude. Constable, for example, subtly adjusted the composition of his documentary, naturalistic 1814 *View of Dedham* to refer to Claude's *Landscape with Isaac and Rebekah*. At the same time, Turner presented an actual view into the Tamar Valley and beyond, in *Crossing the Brook* in distinctly Claudean terms. In consequence, each of their landscapes offered a vision of Britain that could only be wholly understood by an educated elite that would spot and understand pictorial references explicitly designed to elevate actuality. To endorse this elevation, landscapes by both artists were exhibited at Turner's Gallery and the Royal Academy – improbable haunts for *hoi polloi*. Yet while for Constable, nature was self-sufficient – its material fact was all he felt he needed to represent – in Turner's case, accrued observation informed the landscapes he built from a series of particular observations.

Thus Turner's view of *Hampton Court from the Thames* (plate 38) is dashed on to the canvas, the white ground and

Fig.11 J.M.W. Turner *Crossing the Brook* exh. 1815
Oil on canvas 193 × 165.1 N00497

calm,pastoral view, with cattle in the stream, bargemen working and a village with its pub clustered in the lea of a wooded hill, celebrates the unexceptionable normality of rural life, the imminent disappearance of which Oliver Goldsmith had famously mourned in his great poem of 1770, *The Deserted Village*. The *View of Richmond Hill and Bridge* is, however, more portentous than Goldsmith's verse. Here industry is absent, and the bridge, shaded as the sun is rising, becomes a signifier of the civic works which quietly proclaim the civilised virtues of the English. One reviewer (possibly John Landseer) was very taken with this composition, particularly with the way that Turner had 'given a pastoral character to a scene of polished and princely refinement', and wrote how

> We feel delighted with the effects which we here behold "of incense breathing morn". The indistinct distance of mingled groves and edifices with which Mr. Turner here presents us, leaves the imagination to wander over Richmond, and finish the picture from the suggestions of the painter, where another artist would have exhausted his subject, and perhaps the patience of his observers, by the attention which he would have required to the minute accuracy of his distant detail.

There is a great deal going on here. The pastoral, originally an aristocratic and refined genre of classical poetry, here befits a locale previously associated with royalty. The writer assumes an informed spectator can in imagination wander into the landscape, complete it, and understand the elevated vision of nation it presents.

The Thames was central to this exalted, patriotic landscape. In his famous and hugely influential poem, *The Seasons*, published in its final form in 1744 and reprinted in very many editions subsequently, James Thomson had characterised the view over the Thames Valley from Richmond as 'happy Britannia'. It was the synecdoche of nation – and thus very highly charged.

Something akin to Turner's Thames imagery appears in the oil sketches of De Wint, Linnell, Hunt, and Havell, too, while numerous illustrated books devoted to the Thames and other rivers were being published from the end of the

woven texture of which is as prominent as the summarily-painted areas where he blocks out the palace, trees, barges, horses and people, and streaks and strokes colour to point up the local hues of water or brickwork. It is not difficult to imagine this was painted swiftly – the barges, horses and humans would have been in motion, after all – out-of-doors. The contemporary *Barge on the River – Sunset* (plate 39) exhibits comparable characteristics, although here paint has been washed over the support, and a virtual monochrome is only relieved by the orange and red of the bargemen's fire and the sky blue of what may be a banner flying from their mast. The viewpoint of the former scene – looking down the Thames from one of its banks – is comparable to that of the *View of Richmond Hill and Bridge* (plate 37), that Turner exhibited in his own gallery in 1808. The latter matches the *Cliveden on Thames* (plate 36) that may have been on view there the previous year. This

eighteenth century onwards. Andrew Hemingway (who is eloquent on the Thames's totemic status) points out that Samuel Ireland, for example, published *Picturesque Views of the Thames* in 1792, the Medway in 1793, the Avon in 1795 and the Wye in 1797, while Josiah Boydell produced a two-volume *History of the River Thames* in 1794. The river had an established cultural identity, one that was coincident with ideas of what constitutes a nation; its role as the artery down which were transported the goods that guaranteed Britain's economic superiority – its estuary being the point at which nation met world – was enormously important. Turner, studying the Thames and its vicinity in detail in his sketches, elevates this identity by the developing out of those rapidly-executed, momentary works landscapes which were allusive and complex. We can best appreciate *Cliveden on Thames* if we imagine its antithesis: a landscape of conflict and social disorder, a place corresponding to the land of anarchic chaos and

barbarism that France was represented as in the contemporary caricatures of James Gillray. Being at war enhanced the perceived virtues of one's own nation, and Turner showed precisely what was in danger of being lost.

Others understood the significance of rivers, too. In *Flatford Mill* (fig.12), begun in 1816, Constable created his own version of the 'national' river landscape. John Crome's *Moonrise on the Yare* (plate 42) is, among other things, also a painting of a local economy. The River Yare was the artery connecting the important centre of Norwich with the significant port of Great Yarmouth. Crome's barge sails signify traffic along the river, and he deliberately shows the windmills that ground the corn which, thanks to the advanced agricultural practices of Norfolk, local farmers produced in abundance.

Augustus Wall Callcott exhibited *Littlehampton Pier* (fig.13) at the Royal Academy in 1812. Here, too, the place is managed and is a functioning economic entity with

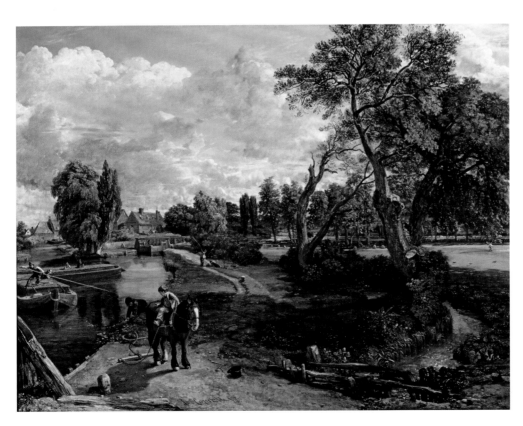

Fig.12 John Constable
Flatford Mill ('Scene on a Navigable River') 1816–17
Oil on canvas 101.6 × 127
N01273

shrimpers, fishermen and, along the shores, what look to be cattle beside a windmill. In addition, Callcott's landscape communicates closely-observed appearances. Colours are local, while the stormy sky suits the squally conditions signalled by the choppy breakers. Here Callcott is creating something more akin to Constable than to Turner: exhibiting, microcosmically, the superiority of the nation not just iconographically, by means of subject, but also by its particular look. In his 1782 *Essay on Landscape Painting*, Joseph Holden Pott stated:

> In this country the merely copying from nature, would of itself give a character to the landscapes of our painters, which would be peculiar, and would sufficiently establish the taste of an English school: for England has undoubtedly many unrivalled and peculiar beauties, many characteristic charms and graces worthy of the pencil.

During the 1800s and 1810s, then, artists sketched in oil from nature, and the knowledge they accordingly gained informed finished paintings by Turner and, subsequently, by others. Turner's works stand apart *because* they formally and iconographically proclaim themselves to be of significant cultural moment. Other artists did not embellish nature to such an extent. Subject and colouring in James Burnet's *View on the Thames* (plate 41) allude to the work of the seventeenth-century Dutch artist Aelbert Cuyp – though this does not detract from the accuracy of Burnet's representation of fishing on the Thames in exceptionally tranquil conditions. The importance of the river and its economy links Burnet's fine work to Turner's, as John Crome's striking *Yarmouth Harbour – Evening* (plate 43) extols the virtues of the harbour both through the 'forests of masts', which traditionally signified flourishing trade and commerce (and, by extension, national civility) and by accurately communicating particular appearances.

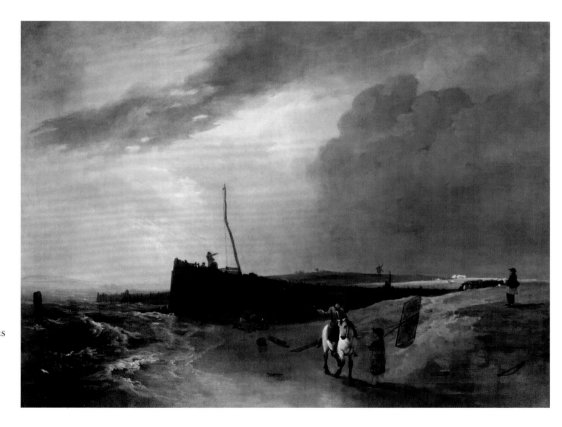

Fig.13 Sir Augustus
Wall Callcott
*Littlehampton
Pier* 1811–12
Oil on canvas
106.7 × 141 N00345

Interestingly, very few of the works from the Tate's collections are unambiguously picturesque, although the picturesque was a fad so fashionable at the time as to be fair game for the satires of Thomas Love Peacock and the barbs of Jane Austen. If George Garrard or John Linnell painted gable ends (plates 28–9), they were indisputably representing the kind of rough, broken, weathered subject that was meat and drink for the *afficionado* of the picturesque landscape. But they were at the same time making oil sketches of actual places, which then may or may not have informed more finished works. The Reverend William Bree's *A Much-Repaired Gate* (plate 31) *is* picturesque, but Bree is representative of the amateur sketcher. And when the superficial similarity with John Sell Cotman's later *The Drop Gate* (plate 30) is examined, the latter looks far more to be concerned with getting the predominant colour, detail and morphology of a particular place right. Perhaps a more apposite comparison would be with Francis Danby's rather sweeter representation of a sequestered stream, the near-contemporary *Children by a Brook* (plate 56).

The high priest of the Picturesque, the Reverend William Gilpin, famously explained that:

> whether I represent an *object*, or a *scene*, I hold myself at perfect liberty, in the first place, to dispose the *fore-ground* as I please; restrained only by the analogy of the country. I take up a tree here, and plant it there. I pare a knoll, or make an addition to it. I remove a piece of paling – a cottage – a wall – or any removeable object, which I dislike. In short, I do not so much mean to exact a liberty of introducing what does not exist; as of making a few of those simple variations of which all ground is easily susceptible…

Little of this happens in these works, however. Their primary concern is with record.

<div align="center">*</div>

The Regency era was a time of seismic scientific as much as artistic or political change. Those who led what Samuel Taylor Coleridge referred to as the 'second scientific revolution' founded their practice on scrutiny and observation as intense as any to which the British landscapists subjected their motifs. Artists and scientists now perceived the world as something yet to be discovered. Its most extreme articulation can be seen in Constable's unprecedented studies of skies (plate 19), with their strong connection to Luke Howard's scientific classifications of cloud types. Constable's campaign of 'skying' was about creating an accurate observational record. There is a paradoxical element here, for skies are always shifting, and the objectivity of these works – these accurate 'snapshots' as we learn from the meteorologist, John Thornes – distilled observations on the weather which Constable collected over thirty or so minutes, which we learn from his inscriptions on these works. On 7 October 1822 Constable wrote to his friend John Fisher that he had 'made about 50 carefull studies of *skies* tolerably large to be careful' (which includes plate 19). The artist inscribed it '27 augt. 11, o clock Noon looking Eastward large silvery [?Clouds] wind Gentle at S. West', matching the actual stormy conditions of that day. When these closely-observed skies combine with landscapes, as they do in *Hampstead Heath with the House Called 'The Salt Box'* (plate 57) – which was painted from the vicinity of Albion Cottage, the house he had rented at Hampstead – the effects are startlingly fresh. Constable's biographer, Charles Robert Leslie, thought this work, painted in the open air, captured the perfection of Constable's landscape during this period. *Hampstead Heath with the House Called 'The Salt Box'* is fascinating in its apparent lack of meaning, save as a representation of a particular place in which life goes on, like his earlier *Brightwell Church and Village* (plate 50). There appear to be no pictorial or iconographic references. This was not always the case in Constable's works: in the 1814 *View of Dedham*, in which Constable manipulated composition to recall Claude, he painted a subject which, while documentary, was also consciously set within a georgic tradition. Likewise, in painting *Malvern Hall* (plate 46) during 1 August 1809 Constable achieved an astonishing freshness, particularly when this sketch is contrasted with Francis Towne's rather earlier, and far more meticulous and methodical, *Haldon Hall, near Exeter* (plate 45). Each,

though, offers the same traditional view of the country house and its role in landscape, and, therefore, of country life. Towne and Constable thus both celebrate the social *status quo*.

Brightwell Church and Village, Hampstead Heath with the House Called the 'Salt Box' take no comparable view – a phenomenon also seen in George Robert Lewis's Hereford paintings of 1815 (plates 51–4). Here there are no elegant shepherds reclining at ease under a tree and piping to their flocks, but instead individualised farmworkers, tending a few sheep rather than a prettily-disposed flock, with the Hereford landscape at harvest time spreading behind them. In the harvesting scene (plate 54), with its ghostly foreground figure, some figures stook the corn, others load a wagon while, in the foreground, a prominent group of labourers do nothing at all but pass round the cider. They contrast strikingly with the far smaller collection of reapers in Constable's closely-contemporary *Fen Lane* (fig.8, p.20), who work with their heads down. In Lewis's world, the poor enjoy a real degree of individual liberty. The close relation of the larger pictures to the oil sketches (which compare in viewpoint with earlier small sketches by Peter De Wint (fig.14), who himself painted fine naturalistic views of harvesting on the open fields in Lincolnshire (Victoria and Albert Museum, London) makes it plain that, though we may be put in mind of the traditional association of harvest with the reward of industry, this is actually incidental. Lewis's chief concern was with painting simply what is. His stressing that he had 'painted on the spot' firmly associated these works with the kind of landscape that Henry Fuseli had, in a lecture of 1804, dismissed 'as the last branch of uninteresting subjects, that kind of landscape which is entirely concerned with the tame delineation of a given spot', namely the topographical. Eighteenth- and nineteenth-century topographical prints often included a printed disclaimer that they were engraved from works taken on the spot, by way of guaranteeing their documentary veracity. These works were deemed to be beyond the pale of a serious, academic landscape painting, which aspired to arouse the imagination and to elevate the ideas of the beholder. The views painted by General George

Bulteel Fisher were even dismissed as 'heartless' and 'atrocious' by John Constable himself in 1826. Lewis, Linnell and their colleagues, then, appeared to be prepared to challenge academic landscapes and, by extension, accepted aesthetic orthodoxies with an alternative as serious in intention, but far more pragmatic and observational, and far more to do with the world as it actually was. They were not interested in imagining a superior version of life, fit for the staging of edifying fables.

This was a very new, almost proto-modernist kind of art. John Crome's *Moonrise on the Yare* (plate 42) not only celebrated the Norfolk economy, but creates an exercise in silhouette and pattern. Around 1808 Croome's fellow Norwich artist, John Sell Cotman, painted an extraordinary shorescape where, in contrast with Callcott and his busy Littlehampton, all is broken down to shape, clutter and colour. It is a way of seeing shared by Thomas Girtin's watercolours, or by William Henry Brooke's summary watercolour of *Lanherne Bay near the Nunnery, Cornwall* of 11 August 1819 (plate 18). Thomas Jones had previously depicted the abstracted patternings of appearance in an Italy in which the traditional associations of buildings and places seemed no longer to register. These successors are landscapes unencumbered by tradition.

The tensions inherent in works by Constable, who makes great art out of painting skies alone, emphasise how extraordinary a departure they were. As early as the 1780s, Thomas Jones sketched the fringes of an ever-expanding London (plate 23), which, under the driving forces of new economies and new technologies, was becoming a new kind of city. Jones filled his foreground with the devastation which development had wrought on the greensward, with a tiny labourer excavating a great heap of dirt in a view towards the buildings rising around Queen Square in Bloomsbury. Some years later (probably around 1815–20), George Robert Lewis (plate 26) showed the same dynamic processes, but from far closer to the building work. At Hampstead, in painting the house known as The Grove (plate 27), John Constable painted the corollary to metropolitan expansion: the relatively new phenomenon of the suburb.

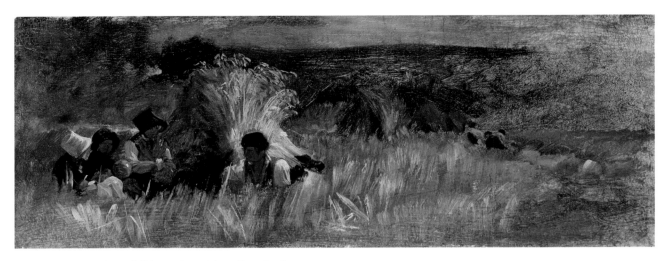

Fig.14 Peter De Wint *Children at Lunch by a Corn Stook* c.1810
Oil on board on wood 13 × 34.9 T07099

By 1815 Londoners were enjoying innovative and spectacular pleasures such as the Panorama at Burford's, where they could imagine themselves in the most exotic spots. You could take the steamboat down the Thames to Margate, which was now beginning to rival Brighton (see plate 20) as one of the new seaside resorts. Modern life demanded new kinds of architecture. There were bespoke dock areas, while in 1799 Thomas Telford proposed a single-span iron bridge to replace London Bridge. Between 1811 and 1816 Sir John Soane designed the first modern, top-lit picture gallery to house the landscape painter Sir Francis Bourgeois's collection at Dulwich College. Until then, art was displayed in private houses. From the outside, the building offers a fascinating assemblage of blocks and cuboids, and is almost devoid of references to the classical orders. It was indisputably modern. The contrast with the stucco capitals, hollow columns and fake pediments of John Nash's contemporary, upmarket housing development at Regent's Park is extraordinarily striking.

Landscape painters, too, appeared (whether consciously or not) to be prepared to paint this world as it was, not as it was imagined culturally to be. But this moment did not last. By the mid-1820s the Bristol painters James Johnson and Francis Danby were creating landscapes (such as

plates 58–9) which drew on the lessons of naturalism, lessons that each had learned sketching from nature around Bristol, to create supernatural places of fantasy. They abandoned the here-and-now: the contrast of Danby's *Romantic Woodland* with the earlier *Children by a Brook* makes this point in an emphatic way. By the mid-1820s Turner was heading down his own path, Constable had had gone far beyond representational naturalism, Linnell had begun moving towards more sentimental landscapes, and G.R. Lewis had given up painting landscapes altogether.

Given that John Linnell was known as a political radical, one might have expected him to paint a radical landscape. But he was not the only one to defy convention. Lewis's landscapes, closely-observed and meticulously-painted scenes which were deliberately set within a tradition of documentary illustration well beyond the pale of fine art, were inherently democratic in being concerned with communicating what *anyone* might see in nature. In this they opposed the hierarchies and order of high art. This kind of observation, looking directly, analytically and as objectively as possible at the world, and trying to paint it, equated to the new spirit of enquiry which underpinned contemporary science. Regency scientists understood that to rely on received knowledge would not do, and that

populations had to accommodate to a world in the process of being discovered, in which established truths would be discarded and in which nothing was fixed. Like contemporary scientists, the artists of the Regency also refuted the traditional ordering of knowledge. They laid claim to a truth which they held to be superior, since it was untouched by the obfuscation or equivocation of such pillars of orthodoxy as the Church of England or, more immediately, the Royal Academy.

For a moment, landscape in Britain became truly revolutionary. For Linnell and his peers this may have been no difficult thing. That Constable, a political conservative who opposed parliamentary reform and Catholic emancipation, and an artist whose landscapes did often conform with compositional and iconographical systems, created such work too (albeit never at his 'own places' around East Bergholt and Flatford) testifies to the exceptional integrity essential in one who would aspire to be a natural painter.

When, in 1828, the writer in the *Literary Chronicle* extolled the supremacy of the British School of landscape, the latter had been eclipsed, and the dominant genre was now the subject picture. With the end of the French Wars, British scenery must have been defused of its heightened charge, and the subsequent agricultural depression must have affected the view. Instead of the challenging modernity of the naturalistic landscape painters, whose works of the 1810s are some of the most innovative in that genre, there was now a retreat. After the Palace of Westminster burnt down in 1834, the government stipulated that its replacement be phrased in a Tudor Gothic style, the architecture of a long-dead era. Turner, aware of what this meant, retrospectively painted the conflagration as heralding the end of the old.

This text is dedicated to the memory of John Gage (1938–2012) and Philip Conisbee (1946–2008).

ACKNOWLEDGEMENTS

Michael Rosenthal would like to thank Jenny Hill, Petra Kayser, Martin Myrone, Steven Parissien, Martin Postle and, in particular, Anne Lyles, Peter Nicholls and Sarah Thomas, who all selflessly read and commented on earlier drafts of this text.

THE ORIGINS AND DEVELOPMENT OF PLEIN-AIR SKETCHING IN BRITAIN, c.1770–1830

Anne Lyles

In August 1831 John Constable wrote to fellow-artist, friend and his future biographer, C.R. Leslie: 'I have bought a little drawing of John Varley, the conjuror – who is now, a beggar – but a "fat & sturdy" one. He told me how to do landscape & was so kind as to point out all my defects. The price of the little drawing was a guinea & half – but a guinea only to an *artist*. However I insisted on his taking the larger sum – as he had clearly proved to me that I was no artist!!'

Constable, the supreme naturalist painter, is referring here to the celebrated watercolourist John Varley, founder member of the Old Watercolour Society in 1804, and a stalwart contributor to their annual exhibitions until his death in 1842 (fig.15). A 'conjuror' thanks to his love of astrology and a 'beggar' owing, no doubt, to his inability to handle money (in 1820 he had been imprisoned for bankruptcy), Varley was also a highly influential teacher. It was in connection with this latter role that he derived his enthusiasm for pontificating on the subject of how best to 'do' landscape. 'Nature wants cooking' was one of his favourite maxims, and he published a number of treatises on landscape painting in watercolours the better to enable his pupils to put this practice into effect. Constable's dry and rather barbed account to Leslie of his meeting with Varley comes, then, as no great surprise. Given the fundamental differences between the two artists' credos and personalities, it was unlikely there would be a close meeting of minds.

However, perhaps Constable might not have been quite so dismissive of Varley had he known (or had he chosen to remember) the latter's earlier, more naturalistic work painted when still under the influence of the watercolour painter Thomas Girtin (fig.16). For both John Varley and his younger brother Cornelius had, in the early years of the nineteenth century, attended the informal drawing 'Academy' run by the physician, collector and amateur artist Dr Thomas Monro at his house in Adelphi Terrace on the Strand, where both Girtin and J.M.W. Turner had studied before them.

Girtin was to die, prematurely, in 1802. However, Monro promoted his work as an important model for the next generation of young landscape painters whose talents he also nurtured, including not just the young Varley brothers but also John Sell Cotman, Paul Sandby Munn, Peter De Wint, John Linnell and William Henry Hunt, amongst others. John Varley inherited from Girtin a sympathy for wide, open panoramic vistas (fig.17), and Cornelius an interest in atmospheric effects (plate 9), inspired by the knowledge that, when sketching from nature, Girtin would 'expose himself to all weathers, sitting out for hours in the rain to observe the effect of storms and clouds upon the atmosphere'. Constable himself, when still young and painting *plein-air* watercolours in and around the Stour Valley and on visits to Epsom in 1805–6, had similarly come under Girtin's influence (fig.18).

However, there was a further, intriguing aspect to John Varley's work and, especially, to his teaching practice, about which Constable may have been unaware. Throughout most of his life Varley painted informal watercolours of landscapes on the edge of the metropolis – and in particular along the Thames at Millbank – which are quite distinct from the rest of his work (which was usually modelled on classical themes), and these seem partly to have been painted on the spot. In his *List of Colours*, 1816, Varley even recommended a suitable paper, of 'rather a rough texture such as cartridge', for the purpose of 'colouring from Nature'.

Furthermore, in the first decade of the nineteenth century, Varley had encouraged his pupils – in particular Linnell, Hunt and Mulready – to make oil sketches in the open air. In the summer of 1806 he rented a house at

Fig.15 John Varley
*Suburbs of an
Ancient City* 1808
Watercolour on paper
72.6 × 97.2 T05764

Fig.16 Thomas Girtin
*Rhyddlan Castle and
Bridge* 1799
Watercolour, graphite and
ink on paper 20.2 × 33.3
T08907

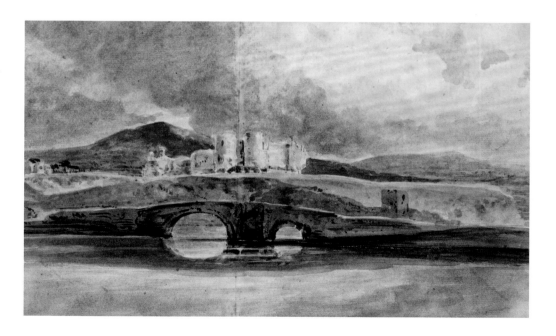

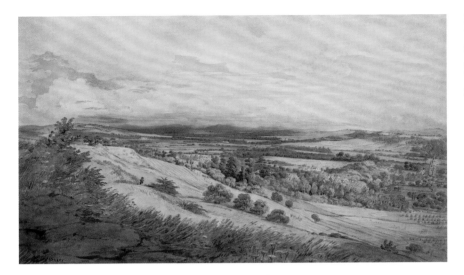

Fig.17 John Varley
View of Bodenham and the Malvern Hills, Herefordshire 1801
Watercolour on paper
31.1 × 52.1 T01024

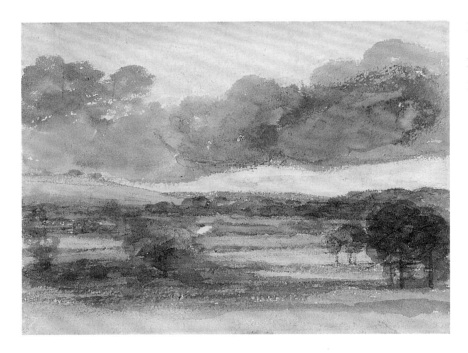

Fig.18 John Constable
View over a Valley, Probably Epsom Downs c.1806
Watercolour and graphite on paper 9.5 × 12.4 T08249

Twickenham, close to the river Thames, where (Linnell later recorded in his *Autobiographical Notes*) he and Hunt 'were always out, weather permitted [sic], painting in oil on millboard from nature'. The remarkable oil studies they made on and around the banks of the river Thames at this date are directly and closely observed (plates 29 and 32–3), and Varley has thus been accorded recognition as the father of *plein-air* painting in early nineteenth-century Britain.

It has sometimes been seen as paradoxical that it should have been Varley – a rather marginal and conventional figure and, furthermore, a watercolourist – who should have played such a key part in helping launch such a significant episode of open-air oil painting in Britain, an enthusiasm which was to last, at intervals, until about 1830.

However, not only had there always been another, more informal side to Varley's own work, but it would also seem that in adopting such enlightened teaching methods he was to a great extent only passing on to his own pupils the sort of tuition he had himself received. For Dr Monro had chosen to instil the lessons of Girtin's pioneering naturalism into his young pupils from Adelphi Terrace by taking them out sketching near his cottage at Fetcham in Surrey (and later at Bushey in Hertfordshire). One of Varley's earliest watercolours to show the pronounced influence of Girtin's style is a *View from Polsden near Bookham in Surrey*, which he inscribed as having been 'made in Company with Dr Monro' and also as a 'Study from Nature' (Laing Art Gallery, Newcastle).

The role of these informal sketching groups and academies, and of drawing masters and teachers (as well, indeed, of sociable gatherings of professional and amateur artists, collectors and patrons), should not be underestimated when attempting to chart the development of *plein-air* sketching in Britain in the period from about 1770 to 1830. For whilst on the continent, and especially in France, sketching in oils in the open air was part of established academic practice, in Britain this was far from the case. Training at the Royal Academy Schools – and at the various artistic societies and academies that had preceded it – emphasised drawing skills, which were chiefly to be honed by studying the human form. Early training tended to revolve round making copies from standard exercise or pattern books or from plaster casts after the Antique, after which the student would graduate to making drawings from the living model. The practice and technique of oil painting featured nowhere in the curriculum of the Royal Academy until, in 1816, it established a School of Painting.

In the late eighteenth and early nineteenth centuries, then, aspiring landscape painters wishing to learn how to use oil paints had to find alternative methods of instruction. One option was to consult published treatises or manuals written by earlier practising oil painters. Another was to cultivate the acquaintance of collectors (or fellow artists) who might own examples of Old Master paintings, and to learn by copying these. (Claude, Poussin, Dughet,

Ruisdael and Rubens were favourite models.) An additional way of learning was to take tips from more established painters, especially Royal Academicians, whether they specialised in landscape painting or not. There was also the option of joining an informal drawing society, such as Dr Monro's Academy in the Strand. The best opportunity, albeit the one that involved the most commitment, was to take an apprenticeship with a practising landscape painter in oils.

Of course these options were not mutually exclusive, and to combine perhaps two or three could, on the whole, only prove advantageous. Constable taught himself how to use oil paints in the 1790s (and to develop his skills in subsequent years) by reading theoretical treatises and practical instruction manuals by, for example, Dutch painter Gerard de Lairesse, *The Great Book of Paintings* (first published in 1707) and Thomas Bardwell's influential *The Practice of Painting and Perspective made Easy* (first published in 1756). He also made diligent copies of landscapes by Old Masters, especially the small Claudes in the collection of connoisseur, patron and amateur painter Sir George Beaumont, with whom he became acquainted at an early stage in his career. He received advice and instruction in the field from Suffolk glazier, plumber and amateur painter John Dunthorne, and he took tips from friendly Academicians such as the landscapist and diarist Joseph Farington and the history painter (and the Academy's President) Benjamin West. Indeed, West had occasionally painted small, fresh landscape oils himself (fig.19), perhaps as a diversion from his more demanding biblical and narrative canvases. He famously advised Constable that 'light and shadow never stand still', a lesson the younger painter claimed never to have forgotten. West also offered encouragement to the young John Linnell, especially admiring some of the novice's *plein-air* chalk drawings of workmen digging in Bloomsbury's Russell Square.

One option Constable decided never to take up, however, was to join any informal sketching society or drawing school. Unlike Turner, Girtin and so many of his other landscape contemporaries, he never became a member of the Monro 'Academy'. Nor did Constable ever pursue a

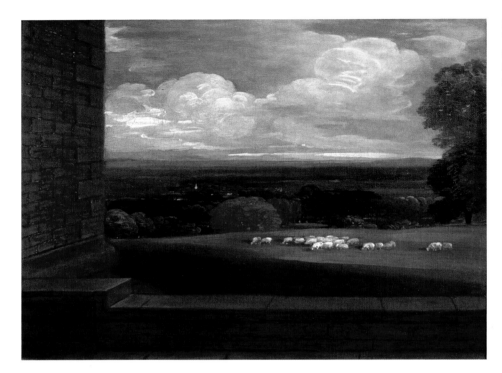

Fig.19 Benjamin West
*View from the Terrace
at Windsor* ?1792
Oil on canvas 28.3 × 37.1
N05310

formal teaching position. However, he did once come close to doing so. In 1802 he applied for a post as drawing master at the Royal Military College at Great Marlow, but then rejected the offer after taking advice from Farington and West. Shortly afterwards, in late May, he confided in a letter written from London to John Dunthorne in Suffolk that to accept the position 'would have been a death blow to all my prospects of perfection in the Art I love'.

This episode caused Constable to think long and hard about his future professional prospects, and he wrote further on the matter in this same, now celebrated letter, which reads like something of an artistic manifesto – not only for the future direction of Constable's own work but also for that of British landscape art more generally at this date. He told Dunthorne he now realised that, as Reynolds had once observed, there was 'no *easy* way of becoming a good painter'. Instead of continuing to make copies after other pictures – a form of 'seeking the truth at second hand' – he wrote that he would return to East Bergholt to make 'some laborious studies from nature.' 'I shall endeavour to get a pure and unaffected representation of the scenes that

may employ me with respect to colour particularly', he declared, for 'there is room enough for a natural painture'.

Few aspiring landscape artists in the early nineteenth century had the luck to secure themselves a position in the studio of a practising landscape painter in oils. This, however, had been the fortune of the young Thomas Jones who, in 1763, entered into terms of pupillage (for two years) with fellow Welshman and landscapist Richard Wilson (fig.20). It would have been during his period of training with Wilson, no doubt, that Jones would first have become aware that the practice of using oils outdoors was, as we have seen, widely adopted by artists in Rome at this date. For Wilson himself had spent time in the 'Eternal city' in the early 1750s, when he came into contact with one of its chief propagandists, Claude-Joseph Vernet.

No oil sketches of Italian landscape subjects by Vernet are known to have survived, nor have any by Richard Wilson. Indeed the latter actually recommended to his pupils that, initially at least, they should restrict themselves to black and white chalks on tinted papers for the purpose of sketching from nature in the open air, so that they might

be 'ground … in the principles of Light & Shade without being dazzled and misled by the flutter of colour'. On the other hand, Joseph Farington, also one of Wilson's pupils, recorded his teacher painting from nature in Moor Park (in a drawing now at the Victoria and Albert Museum, London). So it is not unreasonable to suppose that Jones would have started painting his remarkable oil studies in Wales in the early to mid-1770s at his family home at Pencerrig (plates 2–3), in the full knowledge that such closely-observed external study was widely practised on the continent at this date and was ultimately sanctioned by his own mentor. Jones continued to make similar oil studies, at intervals, throughout his career. The best known of these were executed during his seven year stay in Italy, especially in Naples (plates 5–6). However, he did occasionally take up oil sketching on his return to England, as his view of *The Outskirts of London: A View Looking Towards Queen Square* of 1785–6 testifies (plate 23).

Even if no oil sketches by Wilson himself are known to survive today, he surely relayed the principle of outdoor work to his other pupils. Michael Rosenthal has already cited the watercolour by Thomas Hearne which shows Farington – and also Sir George Beaumont – painting in oils on easel pictures beside Lodore Falls in the Lake District in 1777 (Grasmere, Dove Cottage Trust). However, no *plein-air* oils sketches by Farington are known to exist today, either. On the other hand, various small oil studies by Beaumont of views in the Lake District, where he frequently returned, do survive (Leicester Museum and Art Gallery), and it is assumed that these were painted at least partially on the spot. Some of them are dateable to 1807, as we know that he showed examples of Keswick views to Farington in 1808 – the latter describing them as 'small pictures in oil painted upon *paperboard*'.

Given that the material evidence of *plein-air* oil work in Britain in this period must to some extent be subject to the vagaries of survival, visual documents of artists at work or written references to painterly practice are invaluable aids in helping fill the gaps in our knowledge about its development. Sources such as these also provide useful evidence as to how artists worked on a practical level when painting in the open air – assuming they are reasonably reliable.

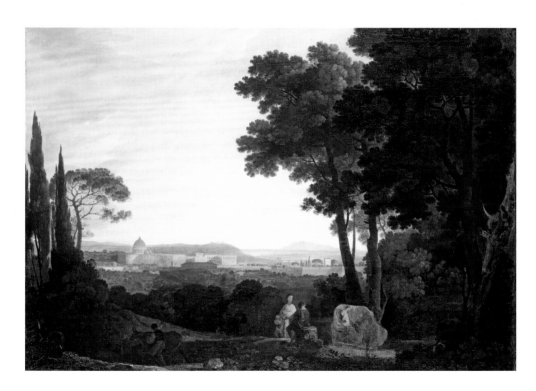

Fig.20 Richard Wilson
Rome: St Peter's and the Vatican from the Janiculum c.1753
Oil on canvas 100.3 × 139.1
T01873

Hearne's watercolour is particularly interesting in this respect. It is also intriguing, as it seems to show Farington and Beaumont at work on medium-sized pictures, resting on easels, and apparently painting onto canvas (stretcher bars are clearly visible to the back of one of the picture supports). They are both shown seated and working under parasols to avoid glare falling across the surface of their paintings. By contrast, Farington refers to the Keswick oils which Beaumont showed him in 1808 as being 'small' and painted on 'paperboard', meaning presumably a type of pasteboard or millboard (boards made in moulds from mixed fibre pulp, in the latter case 'milled' or rolled under pressure). Indeed, bearing in mind the question of portability, it comes as no surprise to discover that artists tended to work on a small scale if at all possible. They also generally preferred to use prepared papers or pasteboards as a painting support rather than more unwieldy or heavy materials such as canvas or wooden boards.

By the early nineteenth century, artists' materials suitable for painting in oils outdoors were beginning to be cited in artists' manuals, and also becoming more readily available from artists' suppliers. This in itself is an indication of how popular *plein-air* painting had become by this date. Paper was particularly suitable for outdoor work, as it was relatively inexpensive, lightweight and durable; but it needed to be prepared in advance, usually with two or three thin coats of oil colour. Although paper could be purchased ready-prepared, some artists, such as Turner and Constable, preferred to prepare their own papers. When, in 1813, Turner made a group of *plein-air* sketches in oils in the vicinity of Plymouth (fig.21) at the instigation of local landscape painter Ambrose Johns, he uncharacteristically worked on papers prepared neither by himself nor by his father but probably by Johns. Some years later, the artist Charles Lock Eastlake reported that Turner was disappointed by the subsequent deterioration of his Devon sketches caused by the discolouration of the ground layers, which distorted the tonal effects.

Pasteboards and millboards could also be purchased at this date from artists' suppliers, ready-prepared with a ground colour and cut to standard sizes. When Constable

first applied himself to *plein-air* sketching in oils in earnest in 1808–10, it is interesting to observe that he turned to millboard as a support as often as to paper (as in, for example, plate 14). It seems likely that in around 1808 Beaumont would have shown his Keswick oil sketches on paperboard to Constable as well as to Farington, thus perhaps stimulating the Suffolk artist's interest in *plein-air* work at this time. Certainly Constable's *View at Epsom*, 1809 (plate 14), as well as being painted on millboard, shares the same strong tonal contrasts that are a striking characteristic of Beaumont's small Lake District oils. If the young Suffolk artist was indeed taking his inspiration from Beaumont here, bearing in mind that the amateur painter had once taken painting lessons from Thomas Jones, this would represent a line of influence stretching back from Constable to Wilson himself and to the whole continental tradition of *plein-air* sketching.

Outdoor sketching in oils could not have been as widely practised as it was in Britain in the early nineteenth century had the paints themselves not been reasonably portable. Of course, artists would have to wait until the middle of the century for the invention of collapsible metal tubes containing ready-mixed paints – an invention which was to transform the process of painting out of doors. However, by the early nineteenth century they were at least to some extent liberated from the laborious process of grinding and mixing oil paints in the studio. For, around this time, colour merchants began to stock bladders, made out of pig's skin, containing ready-prepared oil colours, and these could be packed in portable paint boxes and used relatively conveniently in the field.

Both Constable and Turner owned portable paint boxes like these, examples of which survive to this day. Constable's sketching box has a lid for keeping painting supports in position while in transit; the dimensions of the millboards he used fit neatly into this compartment lid. He also kept a spare piece of millboard in the paint box lid to use as a surface to lean against when painting. This would have been especially useful when he was working on paper, as he would have been able to pin the sheet against the millboard to keep it in position. Sarah Cove has pointed out

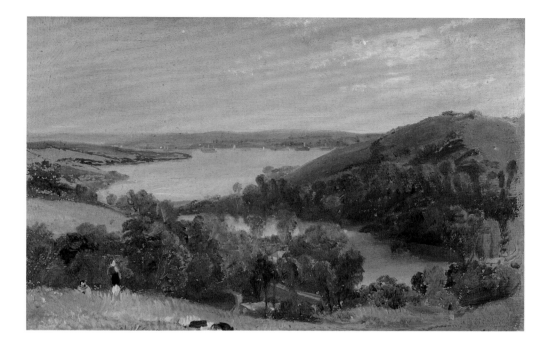

Fig.21 J.M.W. Turner
*Hamoaze from St John,
Cornwall* 1813
Oil on paper 16.4 × 25.7
D09209

that on one occasion, in 1816, when Constable was painting in the open air at Weymouth and was inspired to record the rapidly changing conditions of a dramatic, thunderous sky, he simply seized this spare piece of (unsized and unprepared) millboard and painted directly onto that. (The sketch became *Weymouth Bay, Bowleaze Cove,* now in the Victoria and Albert Museum, London.)

Sarah Cove has also shown that from about the middle of his career Constable began experimenting with different binders to produce faster drying oils – mixing oils with egg, for example, or subjecting linseed oil to heat-treatment – which in turn enabled him to pack his sketches into his paint-box lid when they were 'touch-dry'. Turner painted in oils outdoors much less frequently than Constable, which is presumably why, when finding himself unexpectedly painting in the open air near Plymouth in 1813, he had to depend on the portable paint box (complete with its unreliably-prepared papers) fitted up for his use by Ambrose Johns.

In fact, as we have noted, Turner's most productive and sustained period of *plein-air* painting in oils took place not in Devon but along the river Thames, some eight years

earlier. During his river sketching trip of 1805–6 his boat acted, in effect, as a travelling studio into which he loaded paints, brushes, boards, canvas and a number of sketchbooks, giving him the freedom to swap between painting in oils to watercolour, pencil or pen-and-ink.

The full range of work Turner made on this highly productive excursion – all of which seems to have been painted in the open air, mostly on board the boat itself – has been admirably documented by David Hill. As we have seen, eighteen oil studies on mahogany veneer chart the stretch of Turner's Thames journey from Windsor and along its tributary, the Wey, via Newark Priory and Guildford to the limit of navigation on the river at Godalming (plates 11–13 and 34–5). Then there are fifteen more oil sketches on canvas, featuring views between Richmond and the vicinity of Oxford (of which two are included here, as plates 38–39). Turner also filled five sketchbooks with watercolours and drawings of other Thames scenes observed on both these routes, and later painted and exhibited a number of finished Thames pictures worked up from ideas gathered on the trip (plates 36–37).

Turner's approach to his work on this journey up

the Thames shows a remarkable improvisational and experimental character far ahead of anything Constable had yet attempted by way of *plein-air* work at this date. The panels he chose to paint on are rough-edged and irregular in shape and size, and were perhaps therefore off-cuts acquired from a cabinet maker or, it has even been suggested, salvaged from the construction, or adaptation, of his own boat. Some of them he primed with a chalky material, others he left unprimed, and painted directly onto them. The surfaces were highly absorbent, requiring him to work at speed, and the resulting sketches have a vivacity and freshness that anticipate Constable's outdoor Suffolk sketches of a few years later.

However, the comparison with Constable can only be taken so far. The more one scrutinises Turner's Thames sketches, the more one notices how he has subtly subjected them to the process of picture-making. The format and presentation of *Guildford from the Banks of the Wey* or *A Narrow Valley* (plates 11 and 12), for example, recall classical compositions by Gaspard Dughet, and *The River Thames with Isleworth Ferry* (fig.22) has a tranquillity and sense of pastoral repose that is reminiscent of Claude. Even when sketching from nature, Turner's intuitive instinct was to compose as if with pictures in mind.

Turner's larger Thames sketches (plates 38–9) are even more of a technical feat. Unlike Beaumont or Farington in the Lake District in 1777, who were painting on individual canvases stretched over wooden supports propped up comfortably onto portable easels, in 1805 Turner operated with a single, large roll of canvas. This he would unravel as required, laying the section he needed over a frame to tauten it for painting. He would then proceed to do the same thing for the next section of canvas, without going to the trouble of separating the painted images at this stage. This time, moreover, it seems that Turner did have pictures, even specific ones, very distinctly in mind. For the size of these canvases, when separated, conforms closely to Turner's standard exhibition sizes, leading one to conclude that he was here experimenting with beginning pictures in the open air, painting broad 'lay-ins' (*ébauches*) destined for later completion in the studio.

As already noted by Michael Rosenthal, painting in oils along the banks of the Thames or its tributaries, to the west of the metropolis, became something of a fashion amongst artists around this time. William Havell, whom Turner knew, was engaged in *plein-air* work on the Thames near Reading in the early nineteenth century and, as David Hill suggests, might even have met Turner boating up the Thames on similar business that very year; for although Havell's sketch of *Windsor Castle* (fig.9, p.21) is undated, the Tate also has a small oil study on paper by him of *Caversham Bridge* dated 1805. William Delamotte, who worked outdoors in oils at *Waterperry* near Oxford in 1803 (plate 47), also painted two small, fascinating pictures on the River Thame near Waterperry in 1805 and 1806 (Yale Center for British Art, New Haven), which show a similar degree of finish as the Tate painting. Indeed, when John Varley took a house in Twickenham in 1806 so that his pupils could sketch along the riverbanks nearby, he may well have been taking his cue from some of these other painters.

This circle of artists certainly had many close connections. The exchange of ideas between artists, especially when young, was indeed probably just as influential on their subsequent development as any formal teaching at the Royal Academy. Reynolds, the Academy's first President, had himself acknowledged this in the first of his *Discourses* in 1769 when he argued that 'it is generally found, that a youth more easily receives instruction from the companions of his studies, whose minds are nearly on a level with his own, than from those of his superiors; and it is from his equals only that he catches the fire of emulation.'

Havell was a friend, colleague and near neighbour of William Delamotte, who had taken the post of second drawing master at the Royal Military College at Great Marlow in 1803 (perhaps the very post Constable turned down in 1802). They had travelled in Wales together in 1803, and in 1806 Havell even applied for the post of third drawing master at the Military College (though he failed to secure it). Turner also knew Delamotte sufficiently well, as Michael Rosenthal has pointed out, to visit him in Oxford as early as 1800, when the latter was working as drawing

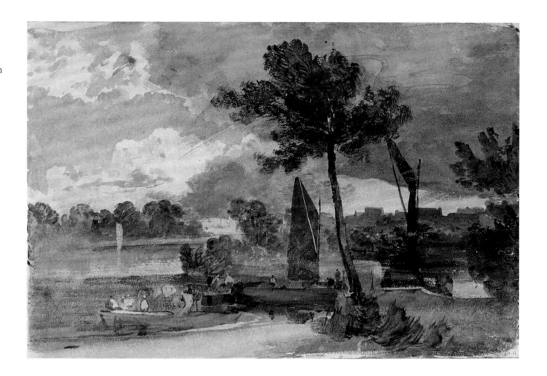

Fig.22 J.M.W. Turner
The River Thames with Isleworth Ferry 1805
Watercolour and graphite on paper 25.8 × 36.6 D05916

master in the city following the death of John 'Baptist' Malchair. Moreover, Delamotte would surely have known John Varley, given that both men were teachers. Indeed it was probably Delamotte who recommended the young William Turner of Oxford to take pupillage with Varley in London in 1804 at the tender age of sixteen, Turner thereby joining a household already accommodating the young Linnell, Mulready and Hunt, whom he would often join on *plein-air* sketching expeditions.

As Michael Rosenthal has observed, Delamotte's *Waterperry* was painted in more than one session; his inscription on the picture even notes the weather conditions over the two consecutive days he made it: 'July 1st: Waterperry. Oxon. 1803 … 1st day cloudy & likely to rain w. Thunder Storms - 2d Day. Weather clearing.w.cloud'. This method of carefully recording the time, place and even the weather conditions for a *plein-air* painting anticipates a practice Constable was later to adopt, and which is best known, and most readily encountered, in connection with his sky and cloud studies (plates 19–20). It is a practice which may have had its origins in the drawing and teaching

methods of John Baptist Malchair and his circle of close friends in Oxford.

Born in Cologne, Malchair had originally come to England in connection with his career as a violinist, eventually moving to Oxford, where he became the leader of a small orchestra. Initially teaching drawing purely to supplement his income, he gradually became a successful teacher in the city, chiefly to undergraduates. His distinguished amateur pupils included Sir George Beaumont (who had gone up to New College after Eton, where he had been taught by Alexander Cozens) and also Heneage Finch, the 4th Earl of Aylesford, whose drawing style was to influence his own friend and neighbour, the Reverend William Bree (plate 31). A wide circle of artists gathered round Malchair in Oxford, half-jokingly referring to themselves as 'The Great School'. Delamotte not only inherited Malchair's teaching role in 1797 (which he occupied until taking up his own post at Great Marlow in 1803) but was also a member of this informal circle of artists.

One of the most talented members of 'The Great School' was the musician and famous child prodigy William

Crotch, who was later to become the first President of the Royal Academy of Music. When he moved from Oxford to London in 1805, Crotch established a friendship with Constable through a shared love of music and drawing. Indeed Constable himself was briefly co-opted as a member of 'The Great School'. It thus seems entirely plausible, as originally proposed by Ian Fleming-Williams, that Crotch transmitted directly to Constable the idea of carefully annotating a drawing with the specifics of time and place (such as the inscription 'June 26, 1807. From behind Wetherall Place/Hampstead' entered on the reverse of fig.23) – in a manner that Crotch himself had inherited from Malchair (fig.23). It was around 1805, when Constable first met Crotch, that Constable himself began to inscribe his drawings and watercolours in this way. One can also imagine Constable admiring the modest but sensitively observant *plein-air* chalk drawings by fellow-East Anglian Thomas Kerrich, the antiquarian, amateur artist and Vicar of Dersingham, who made studies of sky, clouds, sea or coastline which were similarly annotated with details of time and place (fig.24). However, it seems unlikely that Kerrich's drawings would have been known beyond the confines of North Norfolk.

Delamotte's view of Waterperry, painted at least in part from nature, is nevertheless pictorially composed. Even Linnell and Hunt's Twickenham oil studies, though surely painted entirely *plein-air*, are steeped in the vocabulary of the 'Picturesque': close-up views of gnarled trees, broken fences or tumbledown cottages are exactly the sort of rough, random and haphazard naturalistic details recommended in treatises on Picturesque theory (plates 29, 32 and 33). The Picturesque movement in Britain helped serve pave the way for a more objective form of naturalistic landscape at the turn of the century by encouraging artists to scrutinise nature's individual details in the first place.

This was particularly the case for Linnell and Constable, whose youthful exercises in picturesque landscape gradually gave way to a representation of nature almost as pictorially unmediated as it is possible to imagine at this date, bearing in mind, as Ernst Gombrich has so brilliantly shown, that there is no such thing as absolute naturalism in painting. In 1811 Linnell was introduced by Cornelius Varley to a pastor at a Baptist Church in London, and underwent a spiritual crisis which resulted in his becoming a Baptist in 1812. From about this time he began painting simple, unassuming and rather featureless slices of nature with a new objectivity and intensity which has been explained as an expression of Linnell's spiritual reawakening. His reading of William Paley's *Natural Theology* (first published in 1802) helped fashion his new-found belief that to paint God's handiwork meant to paint it exactly as it was.

Now living in the vicinity of Bayswater and Edgware Road (in an area then known as Kensington Gravel Pits), Linnell would turn to painting watercolours of, perhaps, a sunset over a humble back garden (fig.25) or, more mundanely still, of brick kilns in open fields, in which he arbitrarily crops details or seems even to flatten shapes. Indeed the way Linnell presents his subject-matter in these watercolours recalls the simplified compositions of Thomas Jones (plates 5, 6 and 23). However, Jones's small studies in oil always stood apart from his finished classical landscapes painted in the manner of Wilson, remaining strictly as private works painted for his own interest. Linnell's watercolours, by contrast, directly inform the character and presentation of the pictures he decided to work up and exhibit in oils, such as *Kensington Gravel Pits* (see fig.1), which he showed at the British Institution in 1813.

Another factor which may explain the almost 'photographic' sense of realism in Linnell's watercolours at this date is the possibility that, as Michael Rosenthal has noted, they may partly have been made with the aid of optical drawing instruments If they were not actually made with such help, then they were at least influenced by the new way of looking at the world which had been made possible by their invention. These instruments were certainly being used for landscape by artists within Linnell's circle. In 1811 Linnell himself actually purchased a *camera obscura* from Cornelius Varley, and could also have borrowed from Varley an example of the Graphic Telescope the latter patented that same year.

Cornelius Varley had invented the Graphic Telescope specifically for recording landscape, adding to its cousin

Fig.23 William Crotch
Hampstead, from behind Wetherall Place 1807
Watercolour, gum arabic and graphite on paper 11.4 × 17.8
T13239

Fig.24 Thomas Kerrich
Seascape Before Sunset, Burnham, Norfolk 1794
Chalk on paper 14.4 × 22.2
T11957

the *camera lucida* (invented by William Hyde Wollaston) a greater range of magnification and facility for adjustment. One can only be sure that Varley used his telescope for his own drawings if he inscribed them with the initials 'PGT' (for Patent Graphic Telescope). This does not of course rule out the possibility that he used a prototype of the telescope or other optical devices for making some of his other watercolours and drawings (plate 24). The significant fact is that Linnell's and Varley's work at this date shares the same sense of rigorously direct and honest observation.

This spirit of scientific enquiry demonstrated by Cornelius Varley reminds us that Constable, in his search for 'truth' in landscape, also made landscape tracings in his mid-career. Working in the open air, he painted the contours of a given scene onto a pane of glass with brush and ink, then retraced the scene, in pencil, on paper placed onto

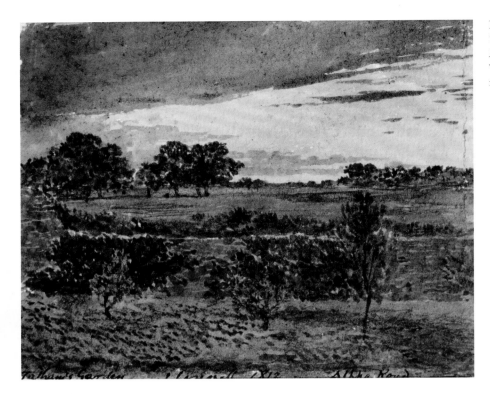

Fig.25 John Linnell
*Tatham's Garden, Alpha
Road, at Evening* 1812
Watercolour on paper
10.2 × 12.5 T04139

the glass. This technique enabled him to record objects at correct distances and in the right relationship to each other – as well as, of course, in accurate perspective. The Tate has a tracing which Constable used in the preparation of his famous picture *Flatford Mill* of 1816–17, which is the largest oil he ever painted substantially in the open air (see fig.12, p.24). It was also the last Suffolk oil Constable completed that had partly been made outdoors. Of course, *Fen Lane* (see fig.8, p.20) was almost certainly painted on the spot as well, probably during the following year. However, it was never finished, as Constable's practice changed significantly in the years after his marriage in 1816.

For most artists, *plein-air* painting was very difficult to sustain on any long-term basis. Not only were there the practical difficulties, but once artists had married and there were children to support, the need to earn a living and the temptation to adapt to the demands of the marketplace usually became overwhelming. (On the whole, the more unadorned a landscape was, the less commercial it proved.) As the amateur artist and intellectual George Cumberland wrote in a letter to his son, expressing his concern that too many artists abandoned their early studies in the open air, 'Work from nature … the moment you quit her, you are lost in landscape painting'.

Constable is exceptional amongst landscape painters at this date for having persisted in *plein-air* painting in oils for so long, continuing the practice in Brighton or Hampstead (plates 19, 20 and 57) until as late as 1829. Ironically, by the time he wrote to C.R. Leslie in 1831, recalling the time when John Varley had called on him and taught him how to 'do' landscape, Constable's own work had become increasingly studio-bound and synthetic. It was to be left to future generations – to the Pre-Raphaelites in Britain and to the Impressionists in France – to see if they could do any better.

ACKNOWLEDGEMENTS

Anne Lyles would like to thank Ian Warrell and Sarah Cove for their help and advice in preparing this chapter.

Sketching from
Nature

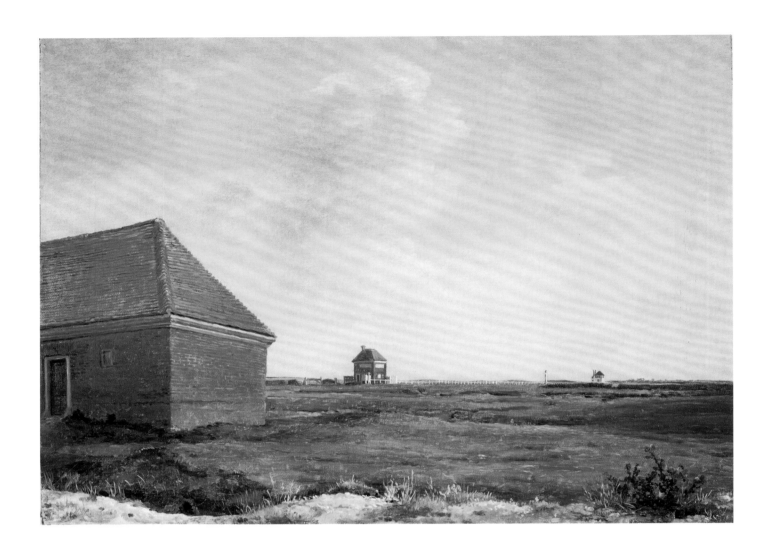

1 George Stubbs (1724–1806)
Newmarket Heath, with a Rubbing-Down House c.1765

Oil on canvas 30.2 × 41.9 T02388

This is one of a pair of small landscapes (the other is at the Yale Center for British Art) that Stubbs painted of the rubbing-down houses on Newmarket Heath, subsequently using these as studio reference works when painting portraits of horses and their jockeys or handlers. After racing, horses were rubbed down of sweat in these bespoke buildings, and Stubbs and his patrons were, presumably, sufficiently concerned with the authenticity of his paintings to wish to make sure that Newmarket was as individually recognisable as the race-horses and their jockeys. This particular rubbing-down house was exclusive to the Jockey Club.

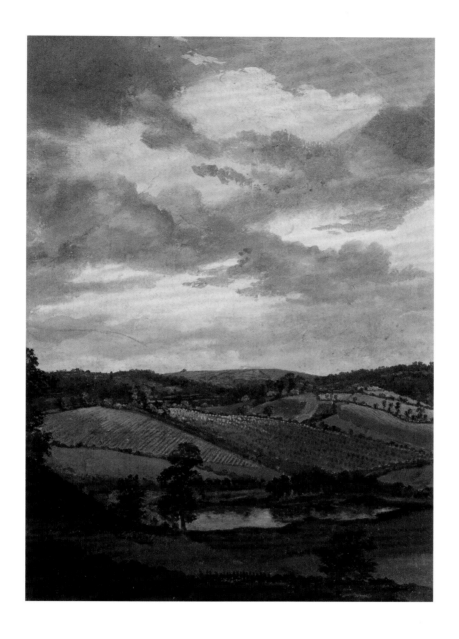

2 Thomas Jones (1742–1803)

Pencerrig 1772

Oil on paper 31.8 × 22.2 T08247

Jones, born into a family of Welsh landowners, had been destined for the church, but the death of a relative released money to pay for his studies with Richard Wilson, whose studio he entered in 1763. There he would have learned about oil sketching from nature, and in this, one of the earliest such works surviving, he already displays his ability to take pleasure and find pictorial interest in landscape regardless of whether or not it fit predetermined aesthetic criteria. He noted in his diary of August 1772 how he had 'spent about 3 weeks at Llandrindod-Wells' making 'a good many studies in oil on paper', suggesting this was a regular and habitual practice with him.

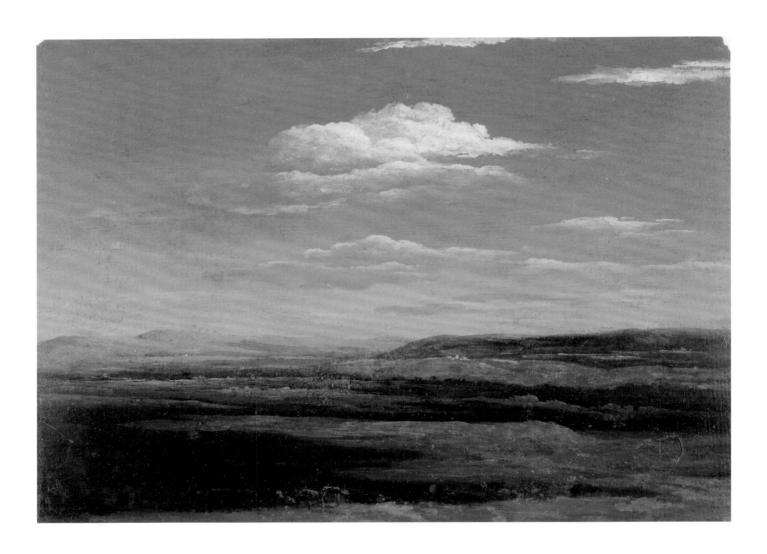

3 Thomas Jones (1742–1803)

Pencerrig 1776

Oil on paper 23 × 31.9 T08243

Thomas Jones aspired to be a classical landscape painter in the manner of his teacher, Richard Wilson (1713–1782). However, he is chiefly remembered today for his original and striking oil sketches, the best known of which were executed on trips home to the family estate at Pencerrig.

 This is one of various vistas that Jones painted during 1776, suggesting a conscious effort to sketch expansive landscapes and the skies which illuminated them. Although many of Jones's oil sketches have been identified, the precise location of the subject of this one is uncertain – although, given that Jones did not go in for topographical invention, it is certain that it represents a particular place.

4 Alexander Cozens (1717–86)

Wooded Coast Scene Date not known

Oil on paper 16 × 18.9 T08045

Alexander Cozens was evidently a close observer of natural effect; the passing shower and the shifting lighting in this scene certainly demonstrate that. The British Museum has some sixteen etchings of landscapes headed *The Various Species of Composition of Landscape, in Nature* probably of the mid-1780s. These associated forms with particular emotions and morals, to suggest that landscape could communicate meaning without resorting to the usual iconographic, formal and compositional references.

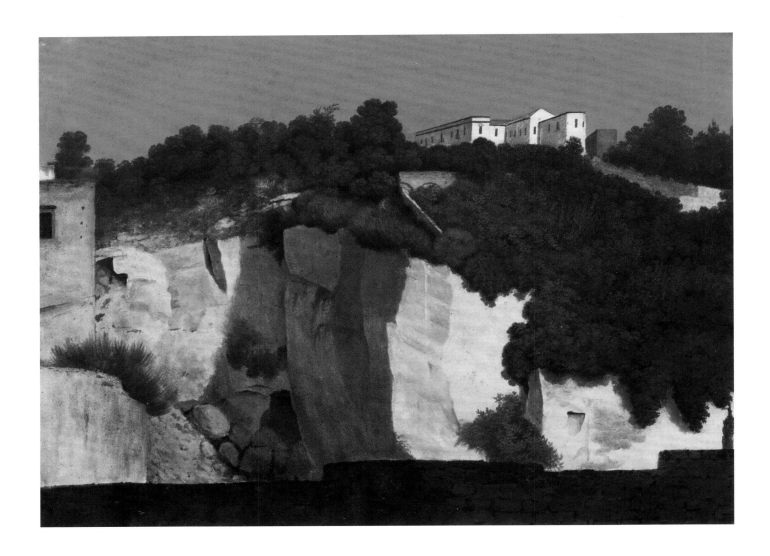

5 Thomas Jones (1742–1803)
Naples: Buildings on a Cliff Top 1782

Oil on paper 28.7 × 38.7 T04872

Like his teacher, Richard Wilson, Jones spent seven years in Italy, from 1776 to 1783. During the last three years of his time there he lived in Naples. This study comes from a group of paintings depicting the view from the flat, parapeted roof of his lodgings, from which he could see a 'great part of the city' as well as 'the Rocks, Buildings, & . . . Vineyards about Capo di Monte'.

 This study, with the cropping of the building to the right and the absence of any conventional organising composition, threw down the gauntlet to those who could only value landscape once it was divorced from common nature. The handling of the paint is very similar to that in comparable studies by Pierre-Henri de Valenciennes, who evidences a comparable delight in the basic colour relations between the sky, cliff and foliage.

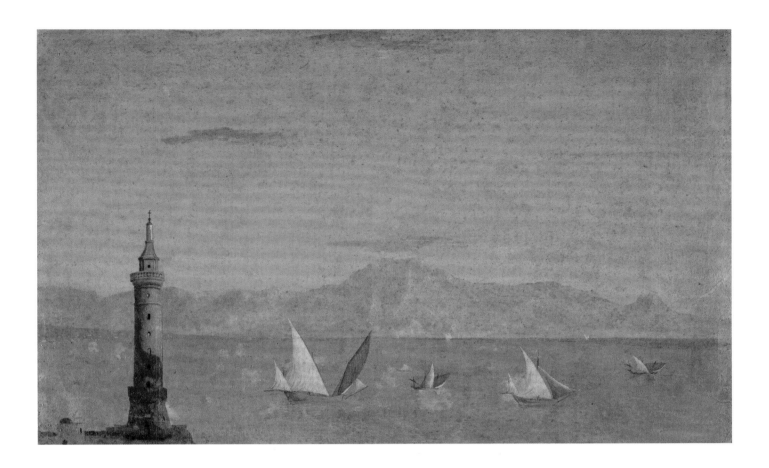

6 Thomas Jones (1742–1803)
The Bay of Naples and the Mole Lighthouse 1782

Oil on paper 24.5 × 39.6 T08246

Jones recorded in his Memoirs that in 1780–2 he took lodgings in Naples in a 'large new built house or Palace' situated opposite the Custom House for Salt, in a noisy area near the old harbour, occupying 'that Part of the second floor nearest the Sea, being by far the pleasantest, with the use of the *Lastrica* or Terras Roof'. His extended visit was partly aimed at securing the patronage of the British ambassador, Sir William Hamilton.

In this view he looks down in a south-easterly direction over the Bay of Naples. Rather than paint a detailed topography of the bay, of the kind in which his friend Giovanni Battista Lusieri excelled, Jones treated his oil paint with the delicacy of watercolour to capture effects of light and colour with extraordinary subtlety.

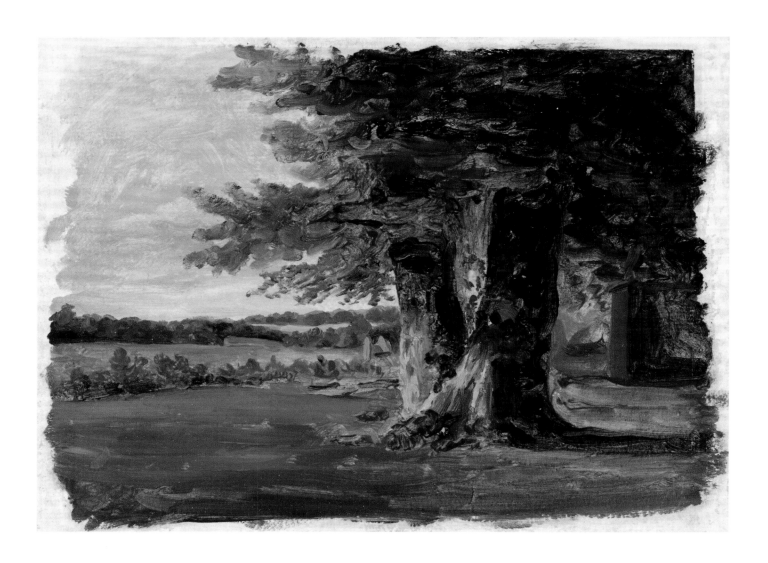

7 George Garrard (1760–1826)
Coombe Hill 1791

Oil on card 13.7 × 18.4 T03299

Garrard was chiefly an animal painter and sculptor. However, in sketches like this – painted at Coombe Hill, south of Richmond Park – he demonstrated an easy facility and accurate eye coupled with a willingness to extract the pictorial from a landscape of unsurpassing ordinariness – a gift that, in certain respects, anticipates Constable's.

8 Sir George Howland Beaumont (1753–1827)
Landscape c.1795

Oil on paper 13.3 × 15.9 T01148

Beaumont had studied landscape under Alexander Cozens at Eton, and was both a reasonably talented amateur artist and a collector of art. (He used to carry Claude's *Landscape with Hagar and the Angel* (1646, National Gallery, London) with him in a specially-designed box, and Constable's encounter with this work in 1795 when he visited Beaumont, then staying with his mother in Dedham, is said to have determined him on becoming an artist.)

 In this sketch – the castle might locate it in North Wales, where he went on sketching tours – Beaumont has worked briskly to capture effect, but has failed to cope with the distortion sunlight forced on his colours. Besides painting, he was a prominent connoisseur (in 1805 he was a founder member of the British Institution) and was later in conflict with some contemporary artists, notably Turner – ostensibly on account of the latter's painting onto white, and not brown, canvas grounds, but more probably because Beaumont objected to a person of low social origins aspiring to high culture.

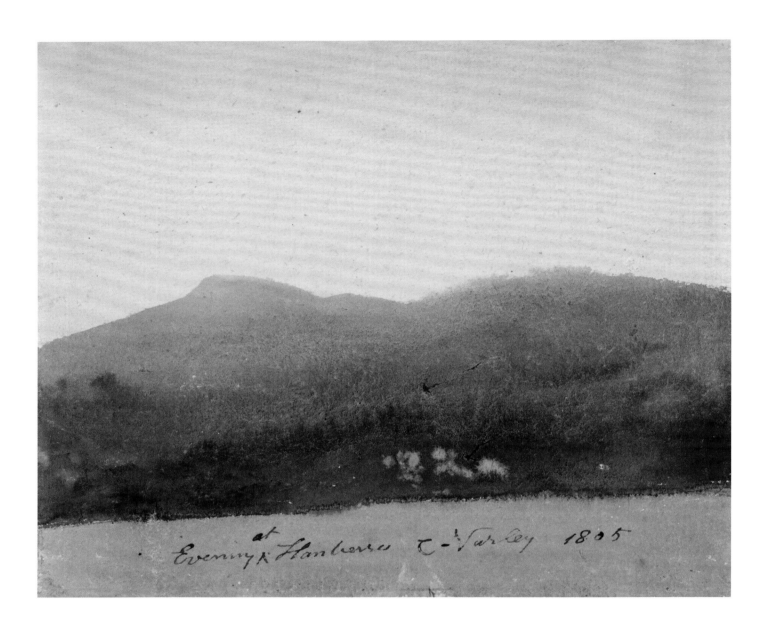

9 Cornelius Varley (1781–1873)
Evening at Llanberis, North Wales 1805

Watercolour on paper 20 × 23.8 T01710

Cornelius Varley was brother of John, who inspired Linnell, Hunt and others to take up oil sketching. He devoted most of his life to making scientific instruments, but in his twenties was also active as an artist. On his 1805 trip to Wales, he wrote detailed accounts of atmospheric conditions which, in certain respects, anticipate those Constable inscribed on his sky studies. Here his concern is with silhouette and light as the sun declines behind the range – an effect he achieves through the subtle control of paint density and hue alone.

10 Joshua Cristall (c.1767–1847)
Fields at Sunset c.1810–20

Watercolour on paper 8.8 × 15.4 T08468

Joshua Cristall, like George Garrard, was not principally a landscape specialist, preferring subject pictures. As a founder member in 1804 of the Society of Painters in Watercolour, an association of artists determined to promote the cause of watercolour painting, he would have known landscape artists, and evidently shared some interests with them, for this watercolour evidences an apparently widespread artistic concern with atmospheric effect.

This fine, almost abstracted work (inscribed 'J.C.', it was formerly attributed to John Constable) uses washes over wet paper to refine the landscape to bands of colour against which lines of trees are smudged, and where the paper serves as a tonal standard in the sky.

11 J.M.W. Turner (1775–1851)

Guildford from the Banks of the Wey c.1805

Oil on mahogany veneer 25.4 × 19.7 N02310

This fine sketch was painted in 1805 when Turner explored the Thames and the Wey by boat. Butlin and Joll write how the 'view has been identified by Christopher Pinsent … as showing Guildford Castle and the eighteenth-century tower of Trinity Church from the banks of the Wey near St Catherine's Chapel; there are chalk quarries on the right.' Turner has represented this view with blocks of paint and a freely-brushed sky to create a study of light as much as of place, displaying extraordinary virtuosity in managing to suggest a wide chromatic range with a relatively limited number of colours.

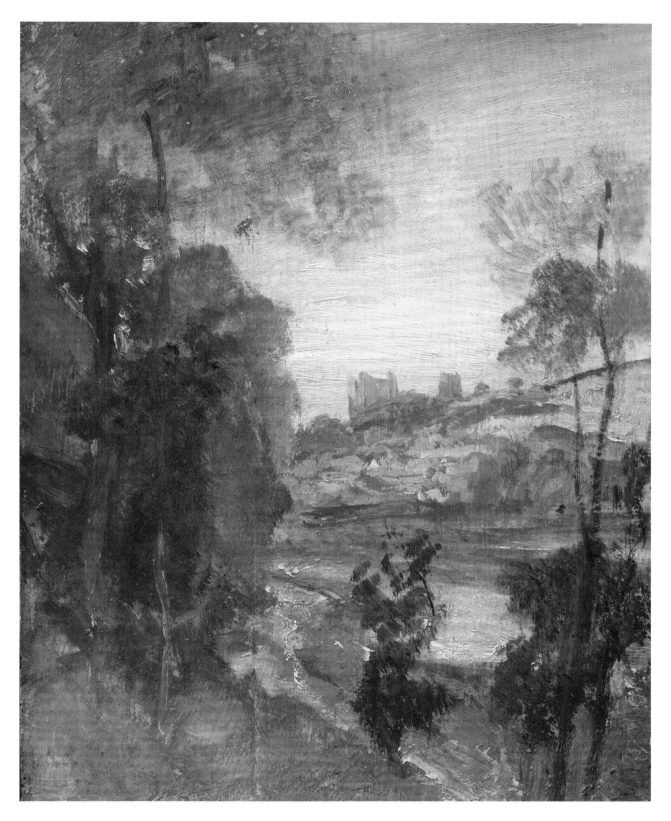

12 J.M.W. Turner (1775–1851)
A Narrow Valley c.1807

Oil on mahogany veneer 20.6 × 16.5 N02303

Turner attacked Guildford from all angles: Christopher Pinsent locates this as being a view of the Surrey town from the south. The composition relates generically to that in Claude's *Landscape with Hagar and the Angel*, the two steeply-wooded hillsides, folding into one another, allowing a summary glimpse over the roofs of the nestling town before the landscape rolls back into the distance.

 The artist was evidently painting at speed: the light brown priming of his support is prominent in areas that his paint missed.

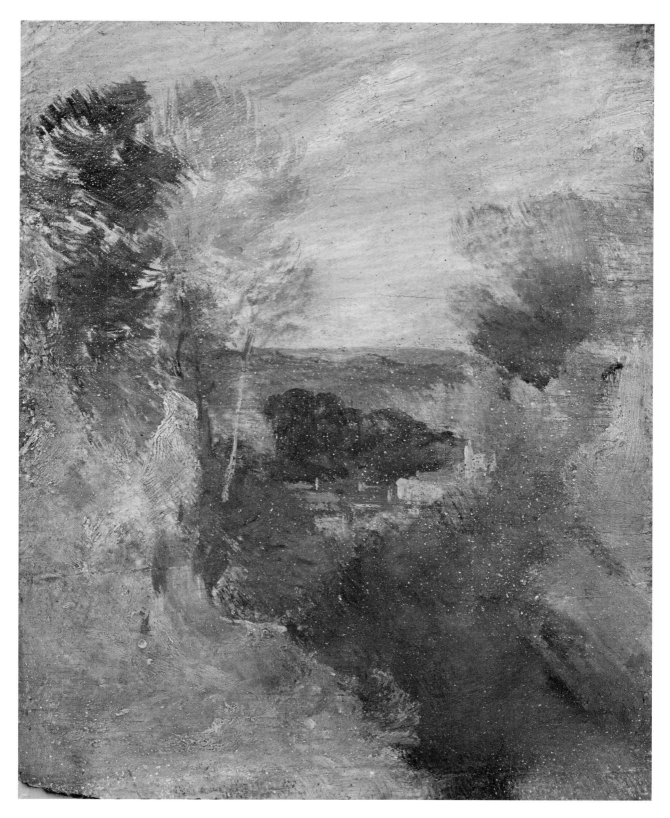

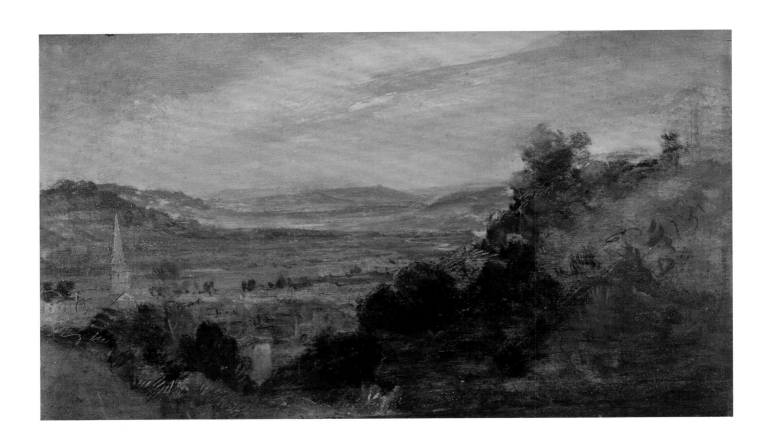

13 J.M.W. Turner (1775–1851)
Godalming from the South 1805

Oil on mahogany veneer 20.3 × 34.9 N02304

During his trip of 1805, Turner took up a position above the town of Godalming, which accents the left-hand side of a vista that stretches away into a greenish distance. This is one of those works that occupies a position half-way between sketch and finished work. There is some drawing, and houses are blocked in; the foreground has been abstractedly marked with the brush end; and dark squiggles related to the outlining of parts of the church serve as pictorial mnemonics. In the distance, rather than depict the hills a conventional blue, Turner has instead painted them a milky green.

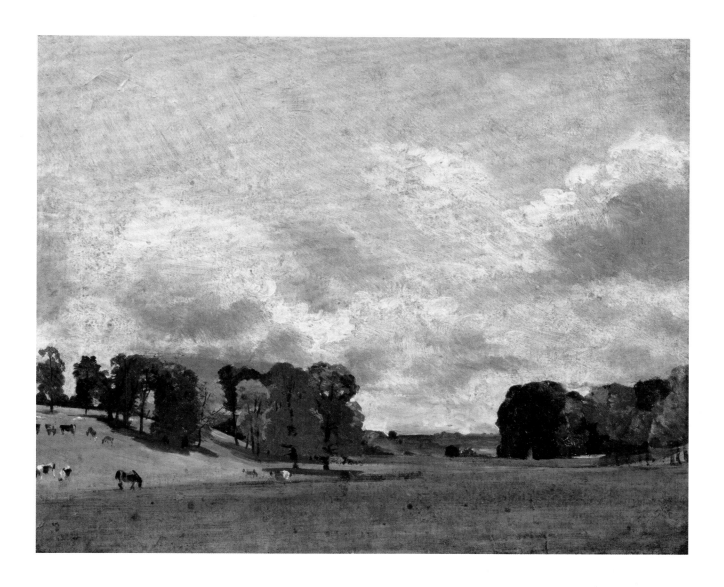

14 John Constable (1776–1837)

View at Epsom 1809

Oil on board 29.8 × 35.9 N01818

Constable's biographer, Charles Robert Leslie, wrote of his landscape being a 'history of his affections' – a concise way of pointing out that Constable tended to paint places in which family and friends lived. Trips to Staffordshire and Derbyshire in 1801 and to the Lake District in 1806 were rare concessions to the rage for touring and painting spectacular and picturesque scenery. In contrast, Constable paid several visits to the more sedate environment of Epsom between 1806 and 1812 to see his aunt and uncle, Mary and James Gubbins. Helpfully, Epsom was accessible from London, where Constable, like most aspirational artists, was based.

 This sketch of cattle and horses grazing in a sunlit valley (which actually could be anywhere) shows Constable on the cusp of achieving the technical virtuosity for which he was known by 1810, and already achieving subtle effects of illumination in his painted scene.

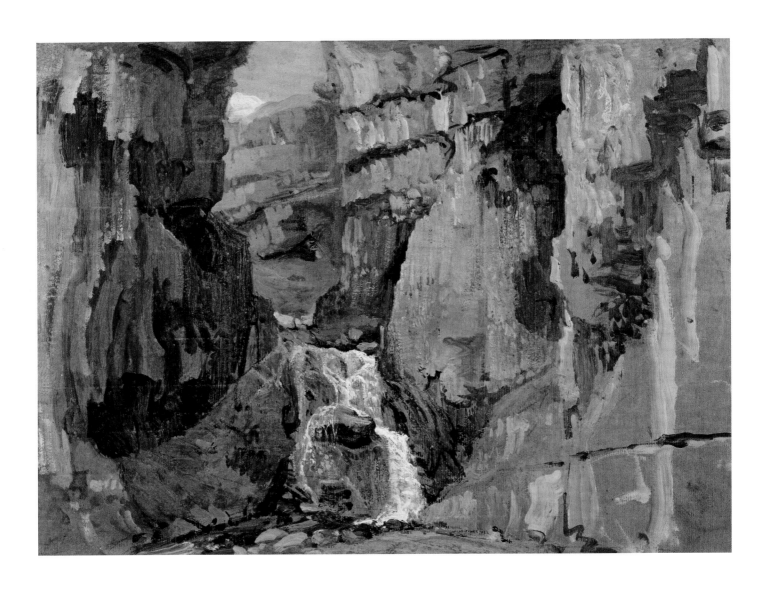

15 James Ward (1769–1859)
Sketch for 'Gordale Scar' 1811

Oil and charcoal on paper laid on board 31.8 × 42.9 N02142

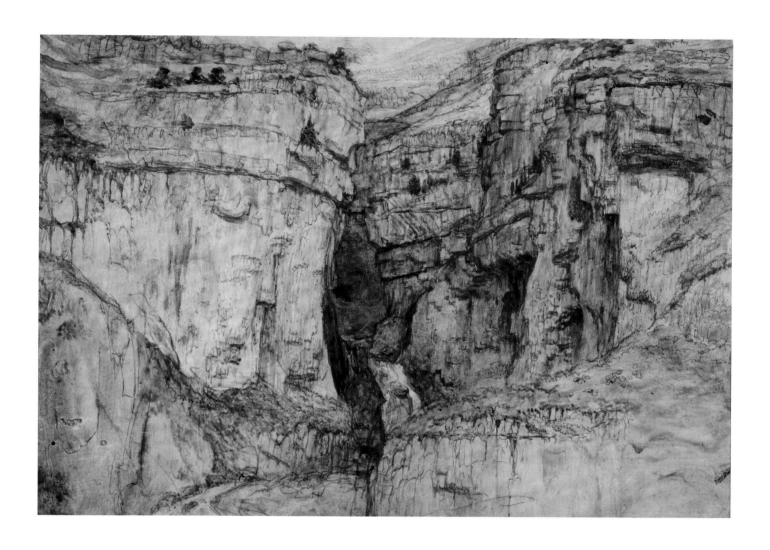

16 James Ward (1769–1859)
Sketch for 'Gordale Scar' c.1811

Oil and wash and graphite on paper 31.4 × 42.5 N03703

In 1815 James Ward exhibited his enormous landscape of Gordale Scar in Yorkshire (fig.26), commissioned by Lord Ribblesdale, who owned the Scar. Edward Dayes had described it as the quintessence of the sublime:

> Good heavens, what a scene, how awful! Imagine blocks of lime-stone rising to the immense height of two hundred yards, and in some places projecting upwards of twenty over their bases; add to this the roaring of the cataract, and the sullen murmurs of the wind that howls around; and something like an idea of the savage aspect of this place may be conceived.

Sir George Beaumont had pronounced the site to be unpaintable, and possibly Ward had decided to show him otherwise. Known as an animal painter, Ward fills the finished work with finely-painted cattle; but in his preparatory studies (of which these are two of many) he concentrated on getting an accurate pictorial knowledge of the morphology of the place. Besides making pencil studies of the whole and its parts, Ward has here resorted to mixed media to get records of colour and geology.

It is probable that these studies combine first-hand observation with studio work. They contribute to a remarkable exercise in subverting art, for it was not normally that 'sublime' landscape was painted onto a canvas of this size – a size which, in France, would be reserved for momentous history paintings.

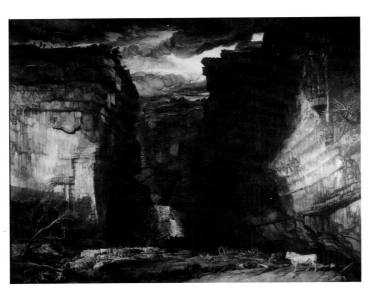

Fig.26 James Ward *Gordale Scar (A View of Gordale, in the Manor of East Malham in Craven, Yorkshire, the Property of Lord Ribblesdale)* ?1812–14 (exh. 1815)
Oil on canvas 332.7 × 421.6 N01043

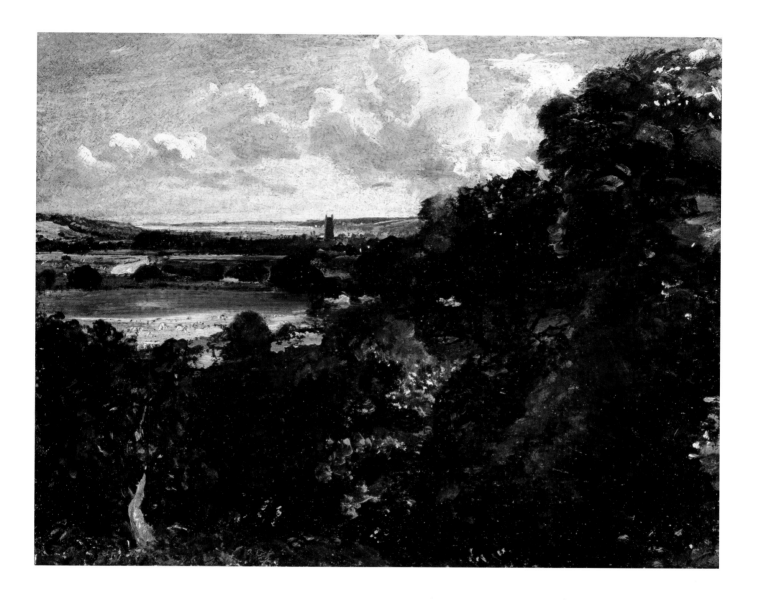

17 John Constable (1776–1837)
Dedham from near Gun Hill, Langham c.1815

Oil on paper laid on canvas 25.1 × 30.5 N01822

The view from Gun Hill, near Langham Church, was one to which Constable returned to repeatedly. It occurs first in
a watercolour of 1800 (Whitworth Art Gallery, Manchester), and was treated as an upright landscape first in one of
those 'laborious studies from nature' that he painted during 1802 (Victoria and Albert Museum, London) and finally
in the large painting of 1828 now in the National Gallery of Scotland.

 The artist had an alternative variant of the scene which featured the bridge over the Stour at Stratford St Mary. This
landscape would have been redolent of personal associations: Constable had gone to school at Dedham, which features
in many other of his landscapes, and this vista surveys a large part of 'Constable's Country', the countryside
surrounding East Bergholt and Flatford, which appears to the left.

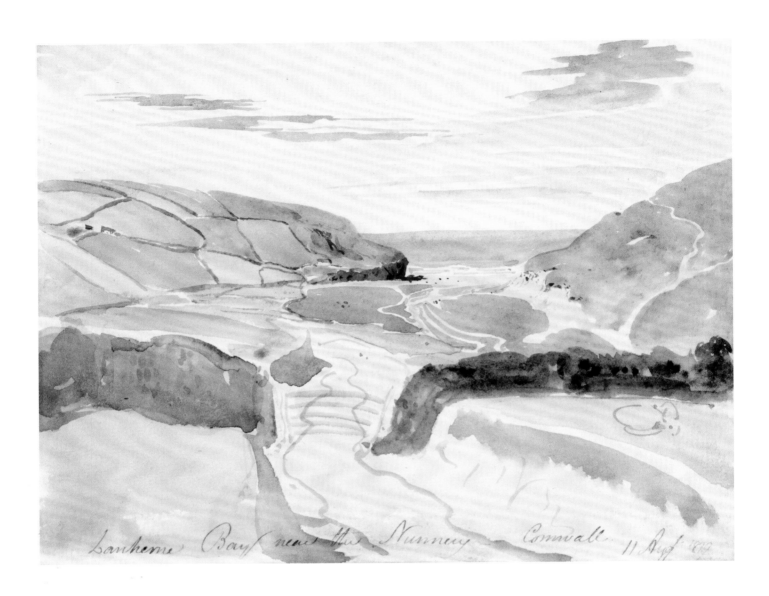

Lanherne Bay near the Nunnery — Cornwall — 11 Aug 1819 (inscription)

18 William Henry Brooke (1772–1860)
Lanherne Bay near Nunnery, Cornwall 1819

Watercolour on paper 146. × 19 T03300

William Henry Brooke was an occasional exhibitor of portraits and figure studies in Royal Academy exhibitions, but is mainly known as a book illustrator and cartoonist, creating political cartoons under the soubriquet 'W.H. Ekoorb.' Brooke did occasionally paint landscapes, and this watercolour of Lanherne Bay, north of Newquay, suggests that he had a real affinity with the genre. There is no invention here. The shapes of the hills and the colours and layout of the fields and stone walls are as true to place as Brooke's inscribing and dating of his watercolour. His control of colour is sufficiently accurate to communicate a real sense of the startling light characteristic of Cornwall.

What Brooke calls 'the Nunnery' is an Elizabethan house, once the home of the Arundell family, and which had, since 1794, hosted a convent.

19 John Constable (1776–1837)
Cloud Study 1822

Oil on paper laid on board 47.6 × 57.5 N06065

John Constable took a house at Hampstead in late August 1819. His wife, Maria, was suffering from tuberculosis, and it was believed that the clean air in what was then an elevated village would be of benefit to her. From then on he painted not just Hampstead Heath but also the skies above it – sometimes with an anchoring strip of landscape, but increasingly not. These studies built on his awareness of the scientific classification of clouds by Luke Howard, and have been shown by John Thornes to have documented the prevailing weather. When he famously wrote to his friend John Fisher in 1822 that the sky is the '"key note" – the standard of "Scale", and the chief "Organ of sentiment"', he was reiterating an orthodoxy that underpinned oil sketching from nature, and had been articulated by Pierre-Henri de Valenciennes.

20 John Constable (1776–1837)
The Sea near Brighton 1826

Oil on paper laid on card 17.5 × 23.8 N02656

Sea air was thought even more beneficial to the tubercular patient than the clean breezes of Hampstead, and in May 1824 the Constables began renting a house in a resort made famous by its association with the Prince Regent (now King George IV). Constable claimed not to like Brighton: in a letter of August 1824 to John Fisher, in which he followed William Wilberforce in disparaging the town as 'Piccadilly by the sea-side' and claiming that there was 'nothing here for a painter but the breakers – & sky'. His willingness to spend a couple of hours in midwinter working on this fine study of a choppy sea accented by maroon sails suggests that these did in fact engage him, His subsequent *Chain Pier, Brighton* (fig.27), which he exhibited in 1827, successfully married maritime nature and maritime modernity.

Fig.27 John Constable *Chain Pier, Brighton* exhibited 1826–7
Oil on canvas 127 × 182.9 N05957

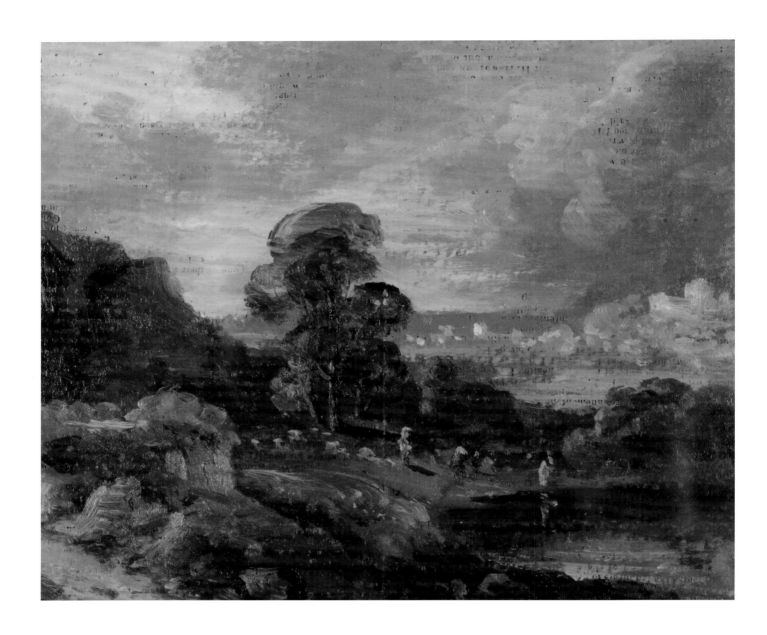

21 William George Jennings (1763–1854)
Heath Scene with a Pond c.1831

Oil on paper 14 × 16.8 T03349

Jennings was a gentleman amateur who exhibited at the Royal Academy between 1797 and 1806 and at the Society of British Artists in 1830. From at least 1826 he was a friend of John Constable and, like Constable, he had a particular attachment to Hampstead Heath. During the 1830s he bought a couple of works from Constable, including *Hampstead Heath with a Rainbow* (fig.28). Jennings understands Constable to be about dramatic skies, chiaroscuro and bright accents of colour, but lacks the finesse of touch to be able to paint anything other than an interesting pastiche.

The sketch opposite is painted on a piece of newspaper, with the print left showing through the paint in places. (On the back is an account of debates in the House of Commons held on 30 June and 1 July 1831.)

Fig.28 John Constable *Hampstead Heath with a Rainbow* 1836
Oil on canvas 50.8 × 76.2 N01275

22 John Constable (1776–1837)
Harnham Ridge, Salisbury 1820 or 1829

Oil on paper 11.4 × 23.8 N01824

This little sketch, which could have been painted on visits Constable made to his friend Archdeacon John Fisher at Salisbury either in 1820 or 1829, adds a little note to the 'history of his affections' as expressed through his landscapes. It demonstrates Constable's unique technical mastery in painting very rapidly (evident from the work on the foliage) yet still achieving a precise rendering of cumulus and altostratus clouds.

This sketch is one of a number he made either from Leadenhall, Fisher's house in The Close, or from its gardens stretching down to the River Avon.

The City

23 Thomas Jones (1742–1803)
The Outskirts of London: A View Looking Towards Queen Square 1785–6

Oil on paper 24.1 × 33 T01929

This is the only survivor from the oil sketches Jones painted after his return to London from Italy in 1783. He was living at Tottenham Court Road when he painted this scene of the development of Queen Square, on land which the Foundling Hospital was selling to speculative developers. Local residents brought a Chancery action to restrain the building, but failed. (The workman in the pit in the foreground suggests that development is imminent.)

Jones, always curious and catholic in choosing his subjects, appears to paint an accurate record of the randomness of the housing development: there is the fence to the right, and buildings standing temporarily isolated to the right. In the left distance are the spires of St Leonard Shoreditch and St Luke, Old Street, while the squat church tower crowned with a turret is that of St. James, Clerkenwell, as it appeared before rebuilding in 1788.

Jones celebrates the momentary. The unstoppable expansion of the city – hinted at in the scarred terrain of the foreground – will soon have all covered in bricks and mortar.

24 Cornelius Varley (1781–1873)
Millbank c.1805

Watercolour and graphite on paper 23.1 × 34.2 T01712

When he was painting this view of engagingly dilapidated buildings on the bank of the Thames (approximately where Tate Britain and the adjacent, giant Millbank tower now stand), Millbank had yet to be engulfed by the ever-growing city, though Varley here hints at the developing of the south bank of the Thames. This fine watercolour reminds us how much more proximate the rural was to the urban during the early nineteenth century. Although the house to the rear left appears to be new, and built of London stock brick, it stands behind more random structures to which bits have been added over the years, and whose gardens are protected by collapsing fences. The scene allows Varley to combine the imminently-urban with icons of the picturesque.

25 John Linnell (1792–1882)
The East Side of the Edgware Road, Looking Towards Kensington Gardens c.1812

Oil on board 36.8 × 38.8 L00864

Linnell was living on the periphery of the city, and here paints collections of buildings in an area that was closely linked to metropolitan development, partly because of the brick kilns located around Kensington Gravel Pits. Here he appears to have been aiming to capture general effects of landscape, and in doing so he has failed to paint the foreground buildings in a sufficiently high key – thus demonstrating that even experienced oil sketchers could occasionally be defeated by natural light.

Thomas Telford's plan for improving and developing Edgware Road – the trunk London-Holyhead route – had recently been published, in 1811, which lends this sketch an added air of impending doom.

26 George Robert Lewis (1782–1871)
Clearing a Site at Paddington for Development c.1815–23

Watercolour and graphite on paper 26.7 × 49.5 T02009

Lewis lived in Paddington, and this drawing, which was almost certainly sketched on the spot and is unfinished, shows the preliminary works made to facilitate the westward development of Edgware Road. The ground is being levelled and earth shifted by manual labour, and, considering the magnitude of the task it has been entrusted to remarkably few men. Nor is there any sign of the horses and wagons one would expect to see being used to cart the earth away. Nevertheless, Lewis effectively communicates a sense of the instability and dislocation attendant upon rapid and expensive development.

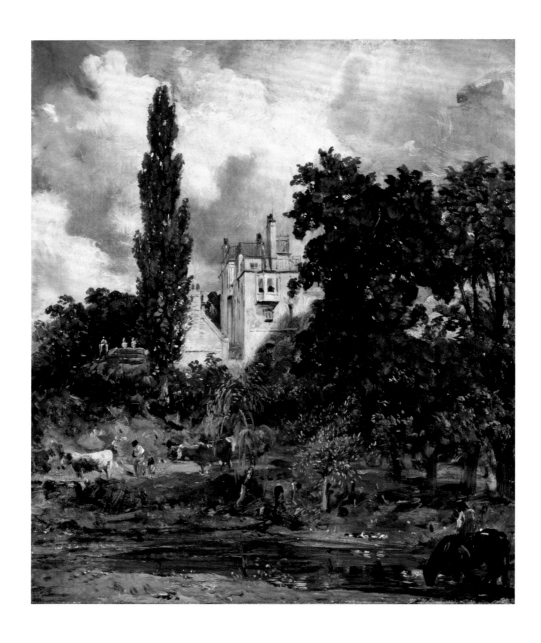

27 John Constable (1776–1837)
The Grove, Hampstead c.1821–2

Oil on canvas 35.6 × 30.2 N01246

Hampstead's suburban environment was pleasingly rural, as Constable's foreground attests. The Grove had been, until 1811, occupied by one Frederick North, a former lieutenant in the navy who had altered the roof to resemble the deck of a man-of-war and was, according to Graham Reynolds, in the habit of 'firing cannon from it on great occasions.' Constable paints the house to supply a commanding accent in the centre of a study notable for the fluency with which tree species are distinguished, and the balance between urban and rural articulated. The painting also makes it plain that Hampstead village was ideally suited to a painter who preferred not to have to walk too far to reach his subjects.

Virtually Picturesque

28 George Garrard (1760–1826)
Mr Taylor's Barn, Marlow *c.1795*

Oil on paper 19.5 × 23.5 T08131

Garrard's barn, with its patched appearance and timber construction, appears superficially picturesque. On closer inspection, however, it is a solid and utilitarian structure, sitting in its own yard, with the rear of a cow visible in the byre to the left. There was an inscription on the original mount revealing that this was 'the original study for the background of the picture of Taylors Fat Cow' – a finished painting, *The Holderness Cow*, was shown at the Royal Academy in 1797.

29 John Linnell (1792–1882)
Study of Buildings ('Study from Nature') 1806

Oil on board 16.5 × 25.4 T00935

Linnell was the pupil and apprentice of the landscape painter John Varley, an influential teacher and central figure in the development of landscape painting in England in the early nineteenth century. Varley encouraged his students to sketch directly from nature in the open air; his much-quoted motto was 'Go to Nature for everything' – and, as Linnell's biographer, Alfred T. Story, records, sent his pupils 'out into the highways and byways to make such transcripts as they could.'

 This study of a ruined gable end, painted with loving attention to the peeling plaster and strips of lath, would be the kind of motif Varley's students would typically fix upon. Leslie Parris quotes a contemporary remembering how 'sitting down before any common object, the paling of a cottage garden, a mossy wall, or an old post [they would] try to imitate it minutely'.

30 John Sell Cotman (1782–1842)
The Drop Gate c.1826

Oil on canvas 34.9 × 26 N03632

Cotman, one of Britain's greatest marine and landscape artists, is highly – and justly – esteemed as a watercolourist, his works in this medium being notable for their simplified geometry and brilliant colouring. He began painting in oil in 1806, and continued intermittently. Oil paint allowed him to build up textures and saturate colours, and to tread a fine line between virtual abstraction and representation. Here the dead-looking tree trunks are natural features which, at the same time, serve as vertical accents and as an antithesis to the bulkiness of the foliage.

His well-known 1805 watercolour of the drop gate at Duncombe Park in Yorkshire (drop gates were designed to impede the movement of cattle along a stream) is in the British Museum; this much later painting features a similar gate but in an unidentified location.

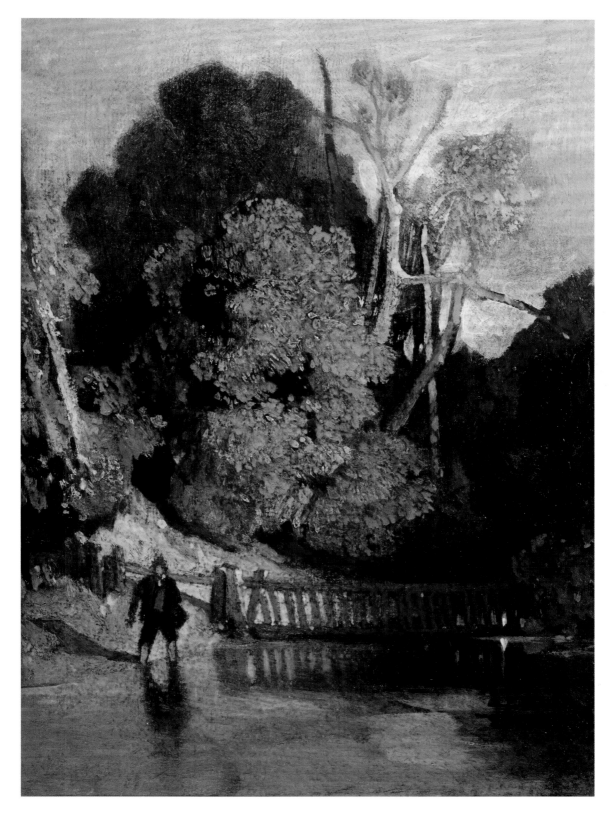

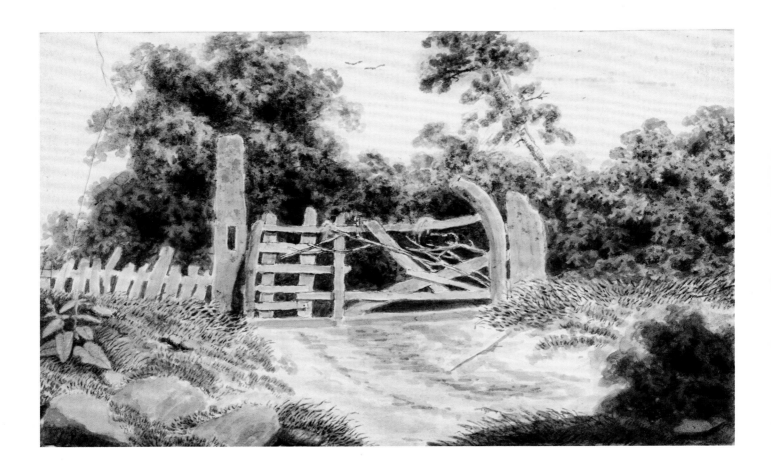

31 Reverend William Bree (1754–1822)
A Much-Repaired Gate 1804

Watercolour on paper 11.4 × 18.7 T05471

William Bree is the kind of artistic clergyman who might have featured in one of Jane Austen's novels. Born at Allesley, near Coventry, he succeeded to the family living in that village in 1808, having already been appointed Curate of Great Packington, Warwickshire. At the latter, he was encouraged in his art by his former Balliol friend and fellow-artist Lord Aylesford, the owner of Packington Hall.

 This virtually monochrome study of a gate is picturesque in manifesting roughness and broken surfaces. At the same time it is also utilitarian: the gate evidently continues to function, and could be transplanted into a more extensive working landscape where it would serve as a perfectly appropriate detail.

Rivers and Coasts

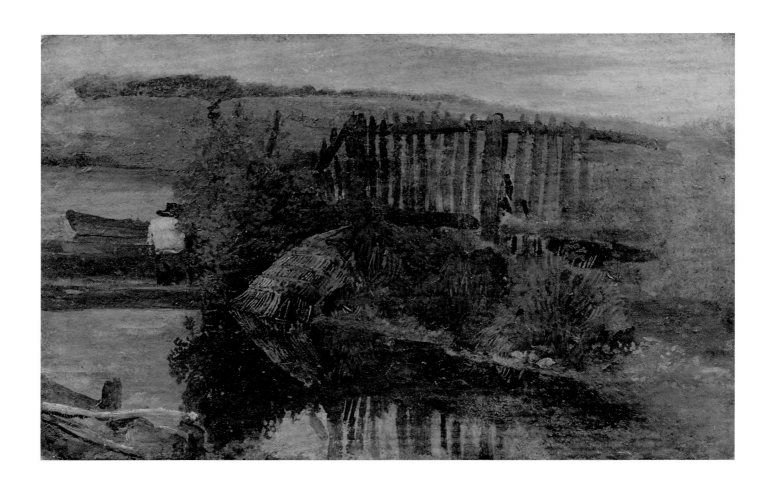

32 John Linnell (1792–1882)
Study from Nature: At Twickenham 1806

Oil on board 16.5 × 25.4 T00934

Linnell here focuses on a detail of the Thames and its economy, such as might be incorporated into a larger painting. We know from Alfred Story that he was painting in company with Hunt at this time (apparently one piece of millboard had sketches by each on either side), and this small sketch appears almost casual in its focus on the paling, the eel trap and the figure of the waterman, his head bent at his work. Linnell had bowed to practicality and worked in a limited number of colours, and yet was sufficiently deft to paint detail and fine line. Here the absorbent support plays a pictorial role, as Linnell allows the board's ground to serve for river bank on the right-hand side.

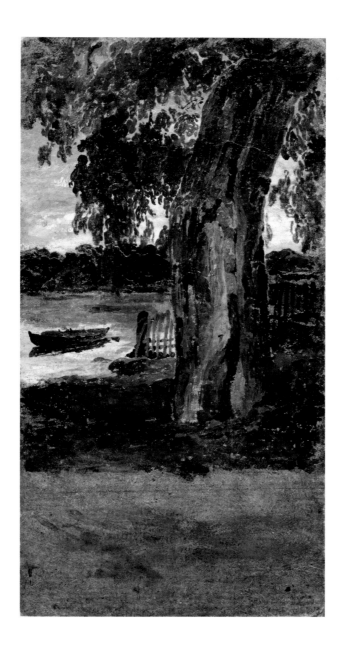

33 William Henry Hunt (1790–1864)
Study from Nature at Twickenham c.1806

Oil on board 33 × 16.8 T01154

Hunt, Linnell's fellow pupil under Varley, records here a 'restricted' vertical view across the river. The semi-hollow tree trunk, painted in narrow vertical strokes of greys and olives is the kind of subject that Valenciennes and others agreed offered real interest to the artistic eye. The trunk blocks the right half of the sketch so that the view then comprises the river with a barge, and the opposite bank, depicted in dark green. Like Linnell, Hunt exploits the accents provided by the repeated verticals of the paling. He appears to have used the bottom quarter of his board to test the grey he used for the river and the tree trunk.

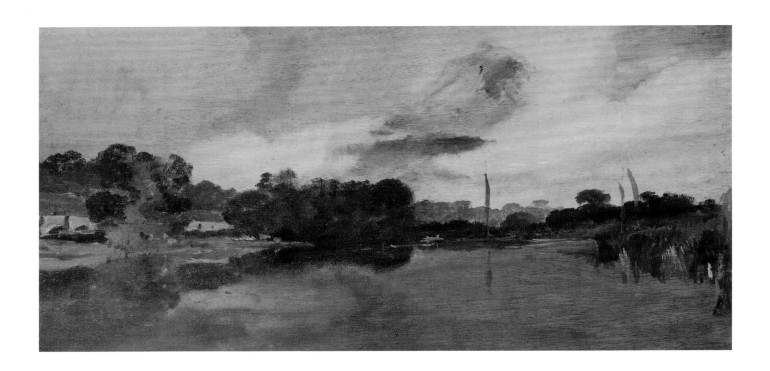

34 J.M.W. Turner (1775–1851)
Walton Reach 1805

Oil on mahogany veneer 36.8 × 73.7 N02681

Turner began making oil sketches on the Thames after leasing Sion Ferry House at Isleworth. In this early experiment in using the oil medium to paint from nature, evidently observed from a boat anchored in a stream, the artist used occasional dabs and blots of colour to approximate the colouration of landscape features. There are brilliantly interesting passages, such as the reflection of the cloud and blue sky in the river, and the manner in which the fold of a sun-streaked line of cloud echoes, in an almost Titianesque way, the gold wedge of what may be a bridge or raised roadway to the left.

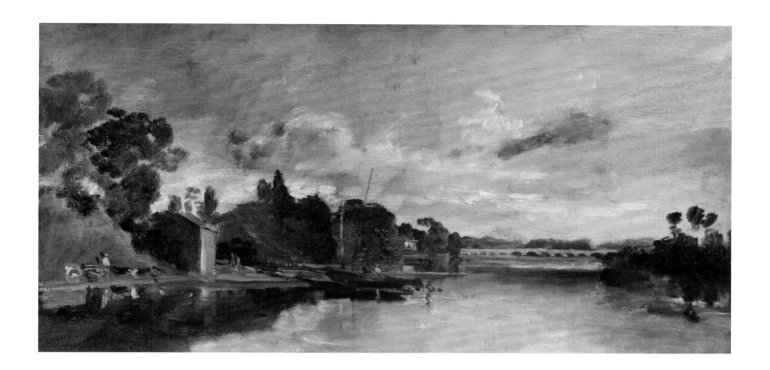

35 J.M.W. Turner (1775–1851)
The Thames near Walton Bridges 1805

Oil on mahogany veneer 37.1 × 73.7 N02680

Closely related to *Walton Reach*, and painted on virtually the same size of wooden support – again from his boat (one wonders if Turner combined painting with one of his favourite hobbies: angling) – this perspective down the Thames culminates in the stretch at Walton Bridge, backed by blue hills. Turner aimed at more specifically accurate detailed work here, noticeably with the horse and cart, the figures in the barge, and the white wall of the distant villa. This concern is evident, too, in the brushwork of the clouds and foliage masses.

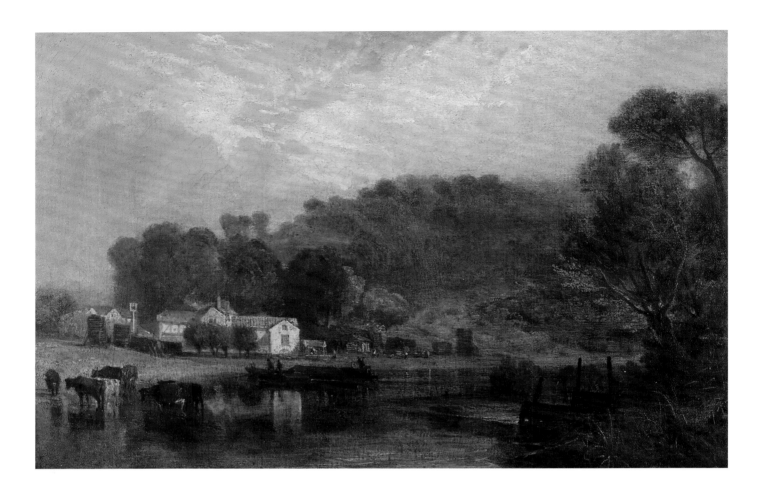

36 J.M.W. Turner (1775–1851)
Cliveden on Thames ?exhibited 1807

Oil on canvas 51.2 × 71 N01180

Turner may have exhibited this modestly-scaled view of Cliveden Reach at his own gallery in 1807. Butlin and Joll note that Benjamin West paid a visit to it that May, and told the diarist Joseph Farington that he 'was disgusted with what he found there; views on the Thames crude blotches, nothing could be more vicious', and suggest that this *may* have been one of the offending works.

The landscape appears to occupy a stage between study and finished work. Certainly Turner has filled it with motifs which would provoke particular associations in the cultivated mind. Cattle cooling their heels in the stream featured in James Thomson's great poem, *The Seasons*, to illustrate a hot day, while the bargemen communicate ideas of industry, commerce and national wealth. On the slopes above this view stood the ruins of Cliveden House, a former home of the Dukes of Buckingham and associated with Thomson, a poet whom Turner admired greatly.

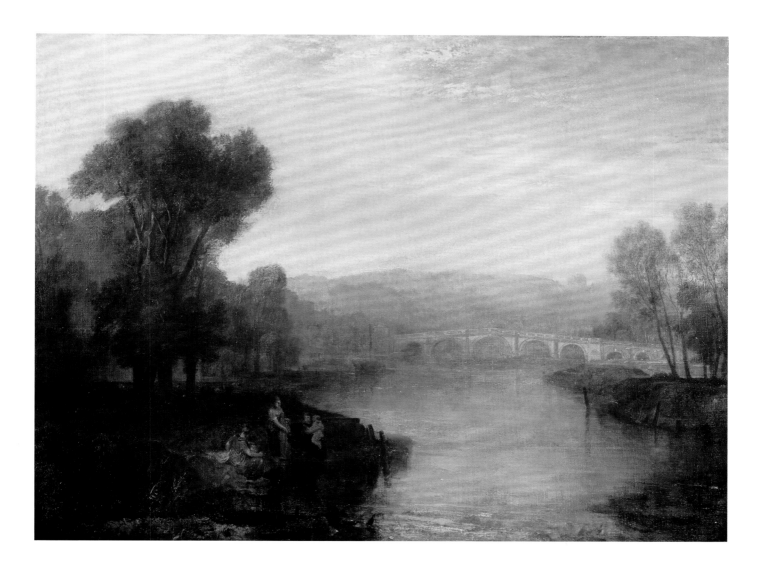

37 J.M.W. Turner (1775–1851)
View of Richmond Hill and Bridge exhibited 1808

Oil on canvas 120 × 151 N00557

Two years after James Paine's bridge was opened in 1777, a journalist wrote how 'connoisseurs in painting will instantly be reminded of some of the best performances of Claude Lorrain', suggesting that the habit of seeing art in nature was common amongst educated people.

 Turner exhibited this work, apparently to general approbation, in his own gallery in 1808. It exemplifies the traditional, academic nature of his landscape practice. Having studied the appearances of the Thames, these studies are here wrought into an allusive, complex and subtly-painted scene of dawn at one of the most association-laden locations along the Thames. In *The Seasons* the poet James Thomson had characterised the view from Richmond Hill as 'happy Britannia' – the landscape of nation.

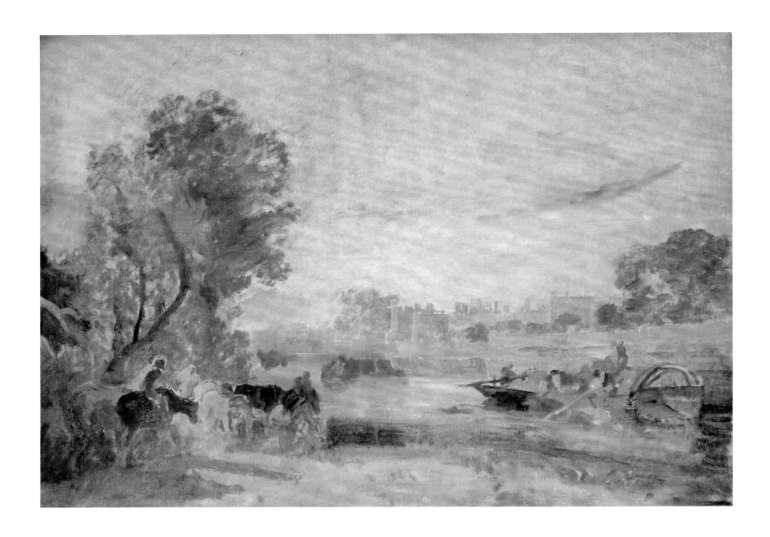

38 J.M.W. Turner (1775–1851)
Hampton Court from the Thames c.1806–7

Oil on canvas 85.7 × 120 N02693

Turner's friend, the Reverend Henry Scott Trimmer, recalled how the former 'had a boat at Richmond … From his boat he painted on a large canvas direct from Nature. Till you have seen such sketches, you know nothing of Turner's powers.'

Turner evidently made this oil sketch from the river bank. It is significant that he is working on a larger scale than the smaller paper or board supports normal for painting *en plein air*. This sketch could easily be adapted into a composed landscape: the tree to the left frames the scene, the river articulates perspective, and Hampton Court Palace forms an object of interest in the middle distance. Moreover, the site's royal and historical resonances make an evocative counterpoint to the commercial modernity signalled by the barge on the river and the group to the left.

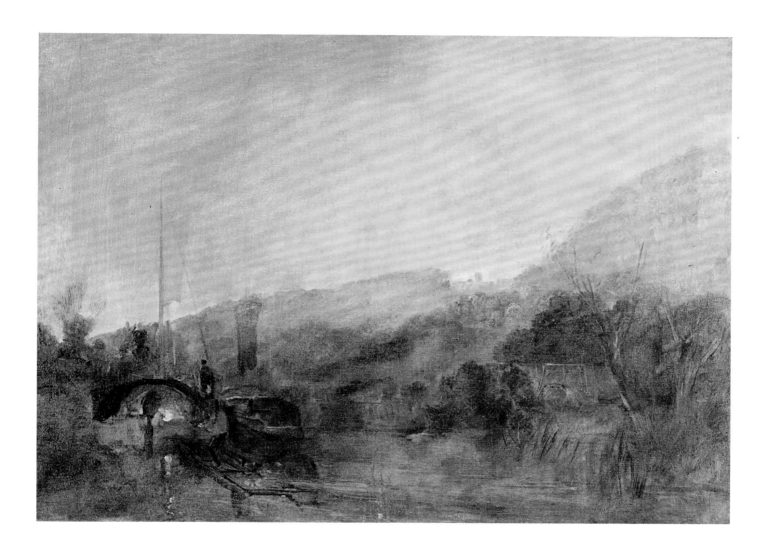

39 J.M.W. Turner (1775–1851)
Barge on the River, Sunset c.1806–7

Oil on canvas 85.1 × 116.2 N020707

Here Turner paints directly onto a light ground. The eye is drawn to the blaze of the fire on the covered barge to the right, the blue of its pennant supplying a striking accent in a scene more generally painted in ochres and browns. Rather than painting subtly to create signifiers of particular form and colour, Turner, while using line to hint at particular forms, concentrates more on silhouette and chiaroscuro to create a landscape of mood.

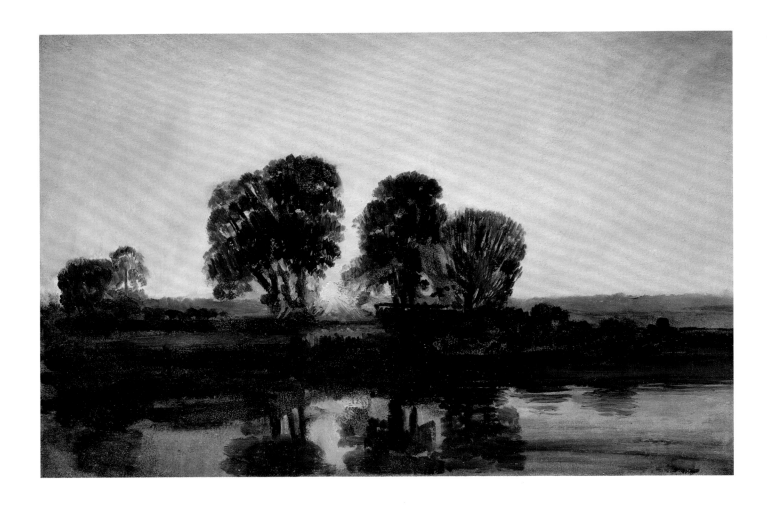

40 Peter De Wint (1784–1849)
River Scene at Sunset c.1810

Oil on paper mounted onto cardboard 30.7 × 46 T07242

Between 1802 and 1808, De Wint was apprenticed to the portrait painter and mezzotint engraver John Raphael Smith, who would take him on fishing expeditions by the Thames, during which De Wint would sketch in oils. De Wint gained an early release from his apprenticeship on condition that he paint eighteen landscapes for Smith over two years. This is one of them, depicting a river which could well be the Thames.

Like John Sell Cotman, Peter De Wint was a watercolour specialist who was equally at home with oil paint. Certainly this landscape sits very comfortably alongside Turner's 1805 *Sunset on the River* (fig.29). De Wint had evidently developed a useful repertoire of marks and techniques for painting trees or reflections on water – the complexity of his surfaces suggest that this painting was achieved after several sittings – while also showing exceptional skill in working with the sunlight in his face yet avoiding producing an entirely dark painting.

Fig.29 J.M.W. Turner *Sunset on the River* 1805
Oil on mahogany veneer 15.6 × 18.7 N02311

41 James Burnet (1788–1816)
View on the Thames ?exhibited 1816

Oil on wood 36.2 × 49.5 N02947

James Burnet was a Scots artist of enormous promise who died from tuberculosis in 1818, at the age of thirty-two.
Born to a most respectable family, Burnet demonstrated an early predilection for painting, and, in 1810 came to
London to improve his skills. As well as studying those old masters available to the view, such as Aelbert Cuyp, he was
also in the habit of working out of doors. This Thames landscape fits within a genre exemplified by some of the
Norfolk river scenes painted by Crome and others, and represents fishermen hard at work in an atmosphere of rare
tranquillity, an iconography associated with Turner's earlier Thames landscapes.

42 John Crome (1768–1821)

Moonrise on the Yare (?) c.1811–16

Oil on canvas 71.1 × 111.1 N02645

John Crome was one of the stalwarts of the Norwich Society of Artists, and well acquainted with the more respectable patrons of that city. He worked as a drawing master in nearby Yarmouth throughout his career, and painted its estuary, harbour and beaches several times.

 In this landscape Crome has clearly experimented with technique and subject. While the paint is sometimes impasted, there are areas where it has been washed so thinly over the canvas that the weave is quite apparent. Crome is concerned with light and silhouettes, too, lining up sails to create interacting patterns or rhyming shapes. At the same time this remains a painting of an actual working landscape.

43 John Crome (1768–1821)
Yarmouth Harbour – Evening c.1817

Oil on canvas 40.6 × 66 N05361

Great Yarmouth was, by the time of the Regency, a major port, with a flourishing fishery, shipyards, breweries and a silk mill. Painting in an idiom adapted from the example of the Dutch painter, Aelbert Cuyp, Crome has painted a scene of latent industry. To the right a vessel is being built, and there are innumerable boats at anchor. Although the colours are true to nature, this painting seems too finished to have been done in the open; certainly the white, red, blue and yellow accents of costume to the right are hardly artless.

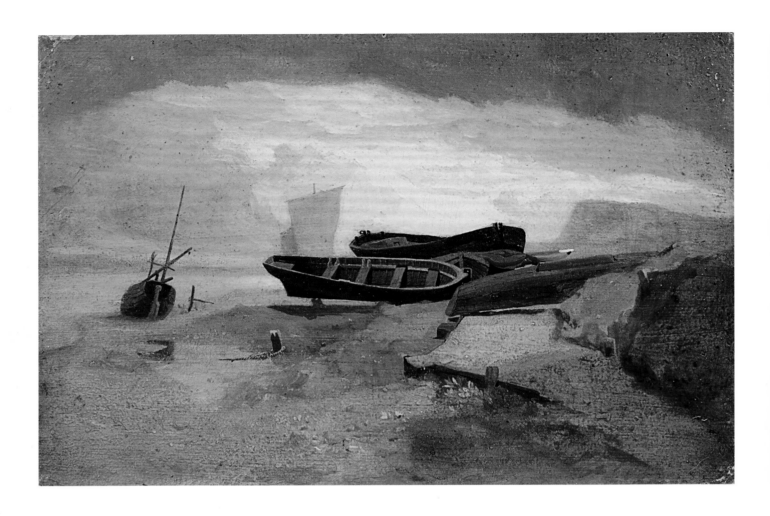

44 John Sell Cotman (1782–1842)
Seashore with Boats c.1808

Oil on board 28.3 × 41 N04785

Cotman possibly painted this at Cromer in Norfolk. Anne Miles, whom Cotman married in 1809, lived two miles away from Cromer, and Cotman exhibited four Cromer subjects between 1808 and 1810.

This painting offers another spectacular distillation of observation in oil paint, which Cotman uses as an opportunity to manipulate geometry, colour and tone. The relationship between the light coming through a clearance in the overcast sky and the illumination of the beach harks back to seventeenth-century precedents such as the seascapes of Van de Velde.

Rural Nature

45 Francis Towne (1739–1816)
Haldon Hall, near Exeter 1780

Oil on canvas 80 × 125.7 T01155

Towne is best known for his elegantly stylised watercolours, but began his artistic career as an apprentice to Thomas Brookshead, a London coach painter. He first went to Exeter in the 1760s, eventually establishing himself there as a drawing master. He also had a line in painting country seats; this particular example was commissioned by Sir Robert Palk in 1780. It is, unsurprisingly, an entirely conventional example of a country house view: the house is set in the distance, commanding a view of cultivated country and patches of woodland to show that under this landlord the countryside was flourishing. Yet Towne eschews the topographical generalisation characteristic of the genre, and paints a scene as green as the Devonshire countryside tends to be.

46 John Constable (1776–1837)
Malvern Hall, Warwickshire 1809

Oil on canvas 51.4 × 76.8 N02653 f

Constable knew the conventions of country house portraiture, and did not deviate from them. The view to the mansion from across a lake had been pioneered by George Lambert in one of his two paintings of Copped Hall in Essex (fig.30), and Constable rehearsed it a number of times.

This celebration of the settled social order is, however, different to Lambert's. Constable apparently painted it quickly, on 1 August 1809; certainly the broadness of brushwork and colouristic range match those of his oil sketches of this period, and there is no evidence that, as was usual, the work was commissioned from the owner.

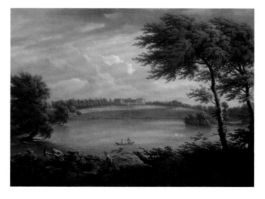

Fig.30 George Lambert (and Francis Hyman?)
View of Copped Hall in Essex, from across the Lake 1746
Oil on canvas 91.7 × 121.5 T07556

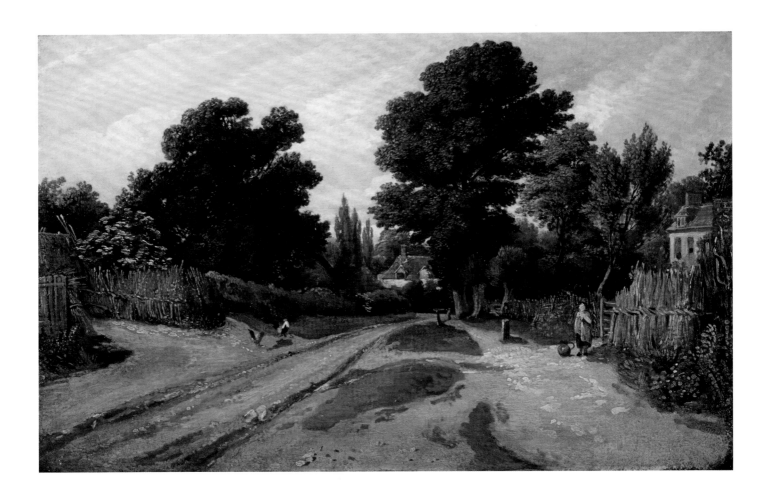

47 William Alfred Delamotte (1775–1863)
Waterperry, Oxfordshire 1803

Oil on board 32.4 × 48.9 T01050

Delamotte, who enrolled in the Royal Academy Schools in 1793, was a noted draughtsman who had, in 1803, become
Drawing Master at the Royal Military Academy at Great Marlow, a post he was to occupy for many years. This
employment gave him the freedom to paint for himself.

 An inscription on the back of this painting – 'July 1st: Waterperry. Oxon. 1803 Wm DelaMotte 1sr. day. Cloudy,
& likely to rain w. Thunder storms – 2d Day. Weather clearing. w. cloud' – reveals that it took two days to execute,
and that the weather was changeable, thus necessitating an element of compromise and generalisation.

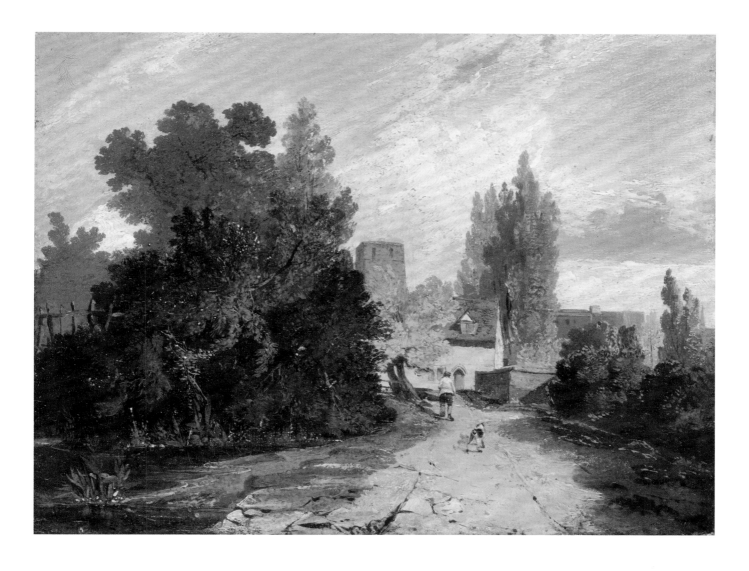

48 Sir Augustus Wall Callcott (1779–1844)
A Road Leading to a Village c.1812

Oil on millboard 19.7 × 26 T05470

Callcott, like Delamotte, was interested in painting humble subjects on a small scale. His close association with Mulready and Linnell meant he must have known about painting from nature, but he apparently elected not to do this because, as he told Samuel Palmer, 'a picture done out of doors must needs be false, because nature is changing every minute'. Instead, he seems to have worked oils like this up from drawings and studies.

Callcott was an interesting and inventive landscape painter. Like Turner, to whom he was close, his subjects ranged from inland to coastal; and, like Turner, he was attacked by Sir George Beaumont and other connoisseurs for being a 'white painter' – painting on white rather than the traditional brown canvas ground. He started painting landscape around 1801, after training at the Royal Academy and working as a portraitist. He joined Thomas Girtin's Sketching Club, and became particularly interested in Turner's early landscape work, developing a parallel and independent interest in the use of a paler palette and clear, luminous colours to suggest atmospheric and light effects on landscape.

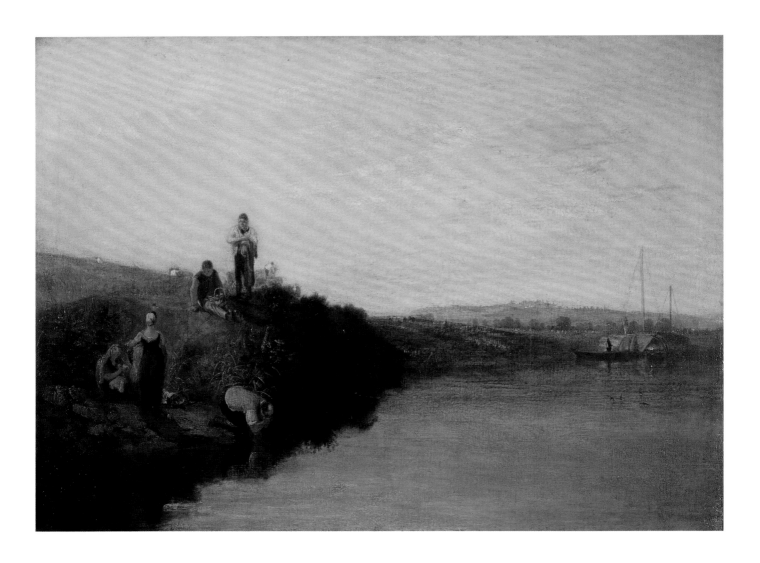

49 J.M.W. Turner (1775–1851)
Harvest Dinner, Kingston Bank exhibited 1809

Oil on canvas 90.2 × 121 N00491

Turner built this work, which he exhibited in his own gallery in 1809, from a slight study of around 1806–7, in which the figures and a laden haywain are the principal objects of interest (fig.31). Although both John Sell Cotman and David Cox admired *Harvest Dinner* sufficiently to make crafty pencil drawings of it, critics at the time appear not to have taken any notice. However, it is a painting that, like G.R. Lewis's harvest scenes, demonstrates real interest in and appreciation of everyday lives.

Fig.31 J.M.W. Turner Sketch for '*Harvest Dinner, Kingston Bank*' c.1806–7
Oil on canvas 61 × 91.4 N02696

50 John Constable (1776–1837)
Brightwell Church and Village 1815

Oil on wood 15.5 × 22.8 T03121

Writing to his fiancée, Maria Bicknell, on July 13 1815, John Constable let her know that he was off to Brightwell, a village near Woodbridge in eastern Suffolk, 'to meet a Gentleman (the Rid. Mr Barnwell of Bury) at a village (Brightwell) . . . to take a view for him – of the Church as it appears above a wood'. Reverend Barnwell had an antiquarian interest in Brightwell, publishing an article on the village in the *Gentleman's Magazine* in 1829, and it is evident that he and Constable established an easy rapport. His view looks north towards the church and includes, on the right, a farm formed from the outbuildings of the demolished Brightwell Hall.

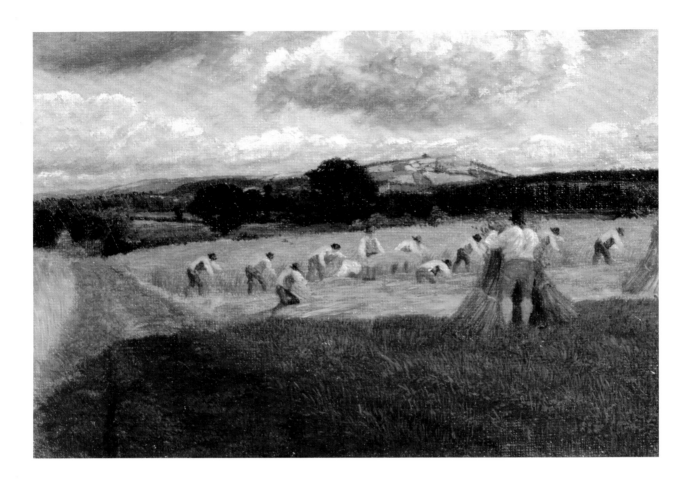

51 George Robert Lewis (1782–1871)
Harvest Field with Reapers, Haywood, Herefordshire 1815

Oil on canvas 14 × 19.5 T03235

Lewis studied with Henry Fuseli at the Royal Academy, and painted landscape only at the beginning of his career, becoming known later principally as a portrait painter after 1820. In the late summer of 1815 Lewis was resident in the Haywood Lodge, a farm near Hereford. During that stay he painted two large pictures and at least twelve smaller oil sketches, which he exhibited at the Society of Painters in Oil and Water Colours in April 1816, announcing them all as 'painted on the spot'. Lewis may have learned the technique of painting *en plein air* from John Linnell when they toured Wales together in 1813.

These sketches are remarkable for their differences as much as their similarities. Lewis appears to have been preternaturally alert to the way that both seasonal appearances and lighting affected the ways that places looked. Plate 51 must have been painted before plate 52, because only a small part of the cornfield has been reaped. Yellow fields on that distinctive distant hill point to harvest yet starting there, too. By the time that the sheaves have been stooked, as we see in plate 54, and the gleaners allowed into the cornfield, that hill, now prospected from a greater distance, has changed its livery. In the earlier sketch Lewis has painted quite thickly, judiciously covering his canvas, although he allows the ground to serve as a mid-tint in his clouds. The later sketch has been painted far more thinly – the canvas weave is almost obtrusive.

Lewis does not scruple to paint the wild flowers, the mess of tools and the clothes on the ground. He also lets us know just how many men were involved in cutting the corn, and (through the sequential arrangement of these works) how long it took. Because the harvest is just beginning in plate 53, this pastoral scene presumably came first.

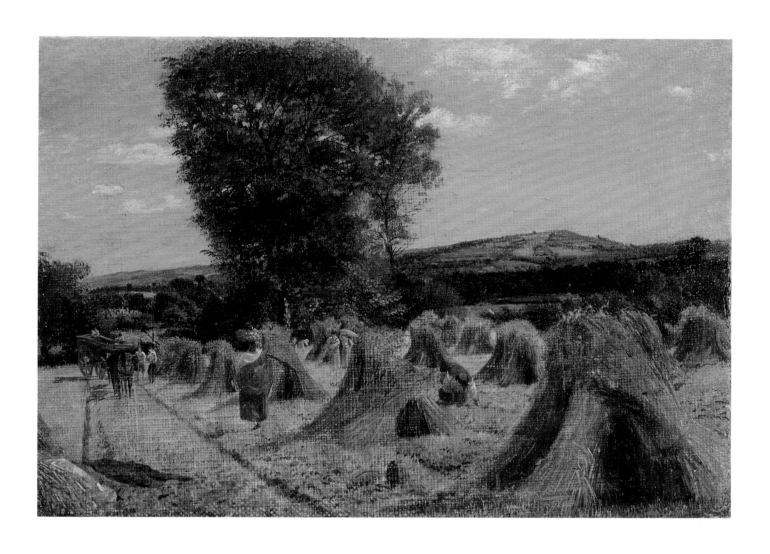

52 George Robert Lewis (1782–1871)
Harvest Field with Gleaners, Haywood, Herefordshire 1815

Oil on canvas 14.3 × 19.5 T03234

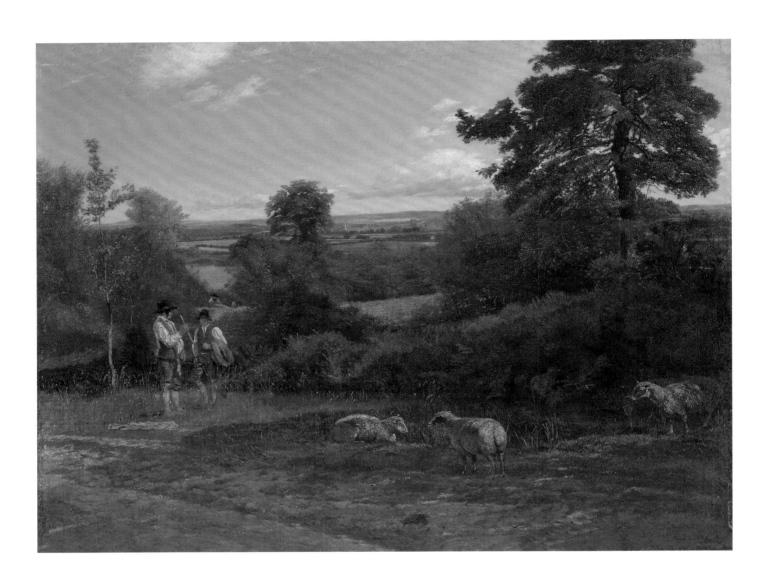

53 George Robert Lewis (1782–1871)
Hereford, from the Haywood, Noon 1815

Oil on canvas 41.6 × 59.7 N02960

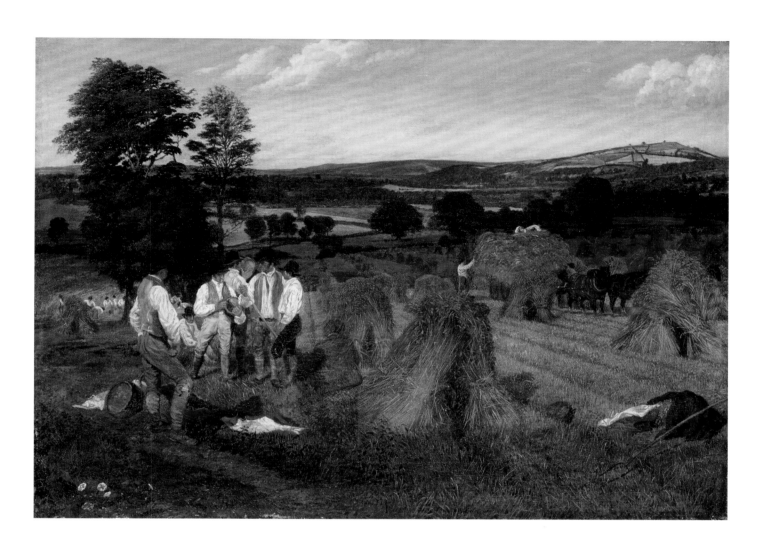

54 George Robert Lewis (1782–1871)

Hereford, Dynedor and the Malvern Hills from the Haywood Lodge, Harvest Scene, Afternoon 1815

Oil on canvas 41.6 × 59.7 N02961

55 John Crome (1768–1821)
Mousehold Heath, Norwich c.1818–20

Oil on canvas 109.9 × 181 N00689 f

Crome frequently painted Mousehold Heath, on the outskirts of Norwich. On the face of it, this is a straightforward and naturalistic landscape in which a couple of rustics prospect heathland bisected by a meandering track. There is far more artifice in this work than is immediately apparent, however. The landscape type recalls examples from seventeenth-century Holland, while the impressive clouds have been arranged to maximum pictorial effect. Even the weeds in the foreground have antecedents in some of Gainsborough's early Suffolk landscapes. Moreover, Trevor Fawcett has noted that Mousehold Heath had been long enclosed when Crome painted this view. Thus this landscape is a fiction and a retrospect, rather than the unexceptionable record of actuality it first appears to be.

Mousehold Heath proved unappealing to Crome's contemporaries, and the painting remained unsold. According to one account, it was cut in two after Crome's death and used as window blinds by another Norwich artist. Another story suggests that a dealer in Windsor had extra figures (including a butcher's boy, driving sheep) painted into it, presumably to make it more saleable.

56 Francis Danby (1793–1861)
Children by a Brook c.1822

Oil on canvas 34.5 × 46 T03667

Francis Danby settled in Bristol in the early 1810s, and appears to have been extremely content there. By 1819 he was
part of a group of artists clustered around George Cumberland, the writer and champion of William Blake. Its
members were in the habit of going on sketching excursions to the local beauty spots, including the Avon Gorge, Leigh
Woods and the Stapleton Valley, where this scene is very probably set. The humid microclimate meant that this locality
was notably lush, and Danby, in the way of Constable, appears to have found such modest subjects worthy of painting.

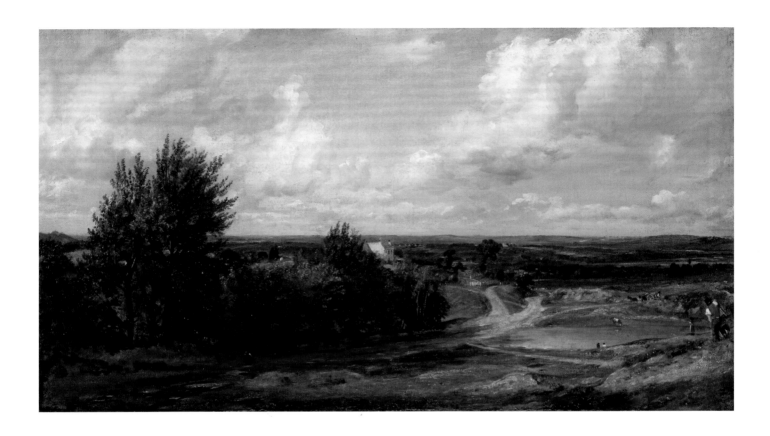

57 John Constable (1776–1837)
Hampstead Heath with the House Called 'The Salt Box' c.1819–20

Oil on canvas 38.4 × 67 N01236

Once the Constables had taken Albion Cottage at Hampstead in 1819, John Constable turned with enthusiasm to the Heath for his subjects. Here he painted many oil sketches as well as several more substantial landscapes. This work was painted from near Albion Cottage, looking to the north-west towards the house known as 'The Salt Box', a prominent residence located on Branch Hill.

This is an exceptional instance of 'pure' landscape, a painting of place and weather with very few discernible narrative elements of the kind evident in Constable's near-contemporary *The Hay Wain*.

58 Attributed to James Johnson (1803–34)
The Tranquil Lake: Sunset Seen through a Ruined Abbey c.1825–30

Oil on canvas 90.2 × 144.1 T01522

Bristol-born Johnson was an architectural draughtsman, watercolourist and painter who, finding it difficult to sell his work, tragically threw himself to his death out of a Bath window aged only thirty-one.

Here Johnson has conjoured a poetic, fantastic landscape. The light streaming through the ruined abbey and the 'antique' figure to the right occupy a place created in Johnson's imagination.

59 Francis Danby (1793–1861)
Romantic Woodland c.1824–5

Watercolour, gum arabic and graphite on paper 19.4 × 26 T08139

Here Francis Danby signals a shift from naturalistic landscape into an imagined world. There is a generic affinity with the German artist Caspar David Friedrich, who also used enigmatic figures to suggest mood and mystery in his landscapes. Although the work has been connected to Danby's visit to Norway in 1825, this forest scene is more suggestive of a psychological or spiritual state than any specific place.

Danby's watercolour confirms that the Regency enthusiasm for sketching naturalistic landscapes *en plein air* had, by the mid-1820s, become unfashionable. This work thus marks both an ending and a beginning.

Bibliography of Works Consulted

Eric Adams, *Francis Danby: Varieties of Poetic Landscape*, New Haven and London (Yale University Press) 1973.

Katherine Baetjer (ed.), *Glorious Nature. British Landscape Painting 1750–1850*, exh. cat., New York (Hudson Hills Press) 1993.

John Barrell, *The Idea of Landscape and the Sense of Place 1730–1840: An Approach to the Poetry of John Clare*, Cambridge (Cambridge University Press) 1972.

John Barrell, *The Dark Side of the Landscape. The Rural Poor in English Painting 1730–1840*, Cambridge (Cambridge University Press) 1980.

John Baskett, Jules Prown, Duncan Robinson, Brian Allen, William Reese, *Paul Mellon's Legacy: A Passion for British Art. Masterpieces from the Yale Center for British Art*, exh. cat., New Haven and London (Yale University Press) 2007.

Ann Bermingham, *Landscape and Ideology: The English Rustic Tradition, 1740–1860*, London (Thames & Hudson) 1987.

Ann Bermingham, *Learning to Draw. Studies in the Cultural History of a Polite and Useful Art*, New Haven and London (Yale University Press) 2000.

David Blayney Brown, *Augustus Wall Callcott*, exh. cat., London (Tate Gallery) 1981.

David Blayney Brown, *Oil Sketches from Nature: Turner and his Contemporaries*, exh. cat., London (Tate Gallery) 1991.

David Blayney Brown, Anne Lyles, Andrew Hemingway, *Romantic Nature: The Norwich School of Painters*, exh. cat., London (Tate Publishing) 2000.

Martin Butlin & Evelyn Joll, *The Paintings of J M W Turner*, revised ed. New Haven and London 1984.

Anthea Callen, *The Art of Impressionism: Painting Techniques and the Making of Modernity*, New Haven and London (Yale University Press) 2000.

Michael Clarke, *The Tempting Prospect. A Social History of English Watercolours*, London (The British Museum) 1981.

Philip Conisbee, 'Pre-Romantic Plein-air Painting' *Art History*, no.24, December 1979, pp.413–28.

Philip Conisbee, Sarah Faunce, Jeremy Strick with Peter Galassi (Guest Curator), *In the Light of Italy: Corot and Early Open-air Painting*, exh. cat., Washington (National Gallery of Art) 1996.

Malcolm Cormack, *Oil on Water: Oil Sketches by British Watercolourists*, exh. cat., New Haven (Yale Center for British Art) 1986.

Alexander Cozens, *A New Method of Assisting the Invention in Drawing Original Compositions of Landscape*, London (J. Dixwell) 1785.

W.M. Craig, *An Essay on the Study of Nature in Drawing Landscape. With illustrative Prints, engraved by the Author*, London (W. Bulmer) 1793.

Trevor Fawcett, *The Rise of English Provincial Art: Artist, Patrons, and Institutions outside London 1800–1830*, Oxford (The Clarendon Press) 1974.

John Gage, *A Decade of English Naturalism 1810–1820*, exh. cat., Norwich (Norwich Castle Museum) 1969.

William Gilpin, *Three Essays: On Picturesque Beauty; on Picturesque Travel; and on Sketching Landscape: to which is added a Poem, on Landscape Painting*, 2nd ed. London (R. Blamire) 1792.

Lawrence Gowing, *Painting from Nature. The Tradition of Open-air Sketching from the 17th to the 19th Centuries*, exh. cat., London (Arts Council) 1981.

Francis Greenacre, *The Bristol School of Artists: Francis Danby and Painting in Bristol 1810–1840*, exh. cat., Bristol (City Art Gallery) 1973.

Francis Greenacre, *Francis Danby 1793–1861*, exh. cat., London (Tate Publishing) 1988.

Louis Hawes, *Presences of Nature. British Landscape 1780–1830*, exh. cat., New Haven and London (Yale University Press) 1982.

Andrew Hemingway, *Landscape Imagery and Urban Culture in Early Nineteenth-Century Britain*, Cambridge (Cambridge University Press) 1992.

Richard Holmes, *The Age of Wonder: How the Romantic Generation Discovered the Beauty and Terror of Science*, London (Harper Press) 2009.

Christopher Hussey, *The Picturesque: Studies in a Point of View*, London (Frank Cass & Co.) 1967.

Thomas Jones, 'Memoirs' *Walpole Society*, XXXII, London 1951.

Charlotte Klonk, *Science and the Perception of Nature. British Landscape Art in the Late Eighteenth and Early Nineteenth Centuries*, New Haven and London (Yale University Press) 1996.

Kay Dian Kriz, *The Idea of the English Landscape Painter: Genius as Alibi in the Early Nineteenth Century*, New Haven and London (Yale University Press) 1997.

John Lord, *Peter De Wint 1784–1849: 'For the common observer of life and nature'*, exh. cat., Aldershot (Lund Humphries) 2007.

Anne Lyles, 'John Varley's Thames: varieties of picturesque landscape c.1805–1835' *Old Water-colour Society's club … Annual Volume*, no.63 (1994) pp.1–37.

Anne Lyles, *Constable: The Great Landscapes*, exh. cat., London (Tate Publishing) 2006.

Kasper Monrad, *Turner and Romantic Nature,* exh. cat., Copenhagen (Statens Museum for Kunst) 2004.

Leslie Parris, *Landscape in Britain c.1750–1850*, exh. cat., London (Tate Gallery) 1973.

Leslie Parris and Conal Shields, *Constable the Art of Nature*, exh. cat., London (The Tate Gallery) 1971.

Leslie Parris, Conal Shields, Ian Fleming-Williams, *Constable Paintings, Watercolours & Drawings*, exh. cat., London (The Tate Gallery) 1976.

Joseph Holden Pott, *An Essay on Landscape Painting. With Remarks General and Critical on the Different Schools and Masters, Ancient and Modern*, London (J. Johnson) 1782.

Graham Reynolds, *The Later Paintings and Drawings of John Constable*, 2 vols. New Haven and London (Yale University Press) 1984.

Graham Reynolds, *The Earlier Paintings and Drawings of John Constable*, 2 vols. New Haven and London (Yale University Press) 1996.

Christopher Riopelle, Xavier Bray, *A Brush with Nature: The Gere Collection of Landscape Oil Sketches*, exh. cat., London (National Gallery) 2003.

Michael Rosenthal, *British Landscape Painting*, Oxford (Phaidon Press) 1982.

Michael Rosenthal, *Constable: the Painter and his Landscape*, New Haven and London (Yale University Press) 1983.

Kim Sloan, *Alexander and John Robert Cozens: the Poetry of Landscape*, New Haven and London (Yale University Press) 1986.

Kim Sloan, *'A Noble Art': Amateur Artists and Drawing Masters c.1600–1800*, exh. cat., London (British Museum Press) 2000.

David Solkin (ed.), *Art on the Line: The Royal Academy Exhibitions at Somerset House 1780–1836*, New Haven and London (Yale University Press) 2001.

Frances Spalding, *The Tate: A History*, London (Tate Gallery Publishing) 1998.

Alfred T. Story, *The Life of John Linnell*, 2 vols. London (Richard Bradley and Son) 1892.

Ann Sumner, Greg Smith (eds.), *Thomas Jones (1742–1803): An Artist Rediscovered*, exh. cat., New Haven and London (Yale University Press) 2003.

John E. Thornes, *John Constable's Skies*, Birmingham (Birmingham University Press) 1999.

Jenniger Tonkovich, *Studying Nature. Oil Sketches from the Thaw Collection*, New York (The Morgan Library and Museum) 2011.

Artists' Biographies

SIR GEORGE HOWLAND BEAUMONT (1753–1827)
Beaumont studied landscape under Alexander Cozens (q.v.) at Eton College, and was both a reasonably talented amateur artist and a collector of art. (He used to carry Claude's *Landscape with Hagar and the Angel* of 1646 – now in the National Gallery in London – with him in a specially-designed box, and Constable's encounter with this work in 1795 when he visited Beaumont, then staying with his mother in Dedham, was is said to have determined him upon becoming an artist.) Besides painting, Beaumont was a prominent connoisseur (in 1805 he was a founder member of the British Institution), a close friend of Joshua Reynolds, and an important early patron of David Wilkie and Benjamin Haydon. The gift of his own art collection to the nation in 1823 helped encourage Lord Liverpool's government to found the National Gallery the following year.

REVEREND WILLIAM BREE (1754–1822)
Bree is the kind of artistic clergyman who might have featured in one of Jane Austen's novels. Born at Allesley, near Coventry, he succeeded to the family living in that village in 1808, having already been appointed Curate of Great Packington, Warwickshire. At the latter, he was encouraged in his art by friend and fellow-artist Lord Aylesford, the owner of Packington Hall and proprietor of the living at Great Packington.

WILLIAM HENRY BROOKE (1772–1860)
Brooke was an occasional exhibitor of portraits and figure studies in Royal Academy exhibitions, but is mainly known as a book illustrator and cartoonist, creating political cartoons under the soubriquet 'W.H. Ekoorb'.

JAMES BURNET (1788–1816)
Burnet was a Scottish artist of enormous promise who died from tuberculosis in 1818, at the age of thirty-two. Born to a respectable family in Musselburgh, Scotland, Burnet demonstrated an early predilection for painting, and in 1810 came to London to improve his skills. As well as studying those old masters available to the view, such as Aelbert Cuyp, he was also in the habit of working out of doors. His untimely death occurred when he was living in Lee, in Southeast London, and he was buried in nearby Lewisham.

SIR AUGUSTUS WALL CALLCOTT (1779–1844)
Callcott started painting landscape around 1801, after training at the Royal Academy (where he worked with John Hoppner) and working as a portraitist. He joined Thomas Girtin's Sketching Club, and became particularly interested in the early landscape work of both Gainsborough and Turner. Elected an ARA in 1806 and a full RA in 1810, Callcott exhibited several landscapes at the Royal Academy and the British Institution in 1811 and 1812. After his marriage in 1827, he and his wife, the writer and traveller Maria Graham, established their Kensington home as one of the capital's most important cultural salons. Calcott was knighted in 1837 and made Surveyor of the Queen's Pictures in 1843.

JOHN CONSTABLE (1776–1837)
Constable was born in Suffolk. His father was a wealthy corn merchant, the owner of Flatford Mill in East Bergholt (the subject of one of the artist's most famous paintings) and, later, Dedham Mill in Essex. Inspired by George Beaumont to become an artist, financial necessity caused him to concentrate on portrait painting after he entered the Royal Academy Schools in 1799. In 1802 he refused the position of drawing master at Great Marlow Military College, a move which Benjamin West advised would mean the end of his career; the post instead went to William Delamotte. The death of his parents and his subsequent inheritance meant that, from around 1818, he could focus on landscapes, and in 1819 he was elected ARA. In 1821 he showed *The Hay Wain* (a view from Flatford Mill) at the Royal Academy's exhibition, and it was bought for exhibition in Paris in 1824. His wife,

Maria, died of tuberculosis after the birth of their seventh child in 1828, and thereafter Constable only wore black. He was elected a full RA in 1829, and from 1831 lectured regularly at the Academy and the Royal Institution.

JOHN SELL COTMAN (1782–1842)

Cotman, one of Britain's greatest marine and landscape artists, began painting in oil in 1806, and continued intermittently. Born in Norwich, the eldest son of a prosperous silk merchant and lace dealer, he refused to go into the family business and instead moved to London in 1797 to pursue a career in art. At Thomas Monro's Adelphi salon he met J.M.W. Turner, Peter de Wint and Thomas Girtin, whose sketching club he joined. He first exhibited at the RA in 1800, but in 1806 returned to live in Norfolk. From 1824 he built up a large collection of prints, books, armour and ship models at his large house St Martin's Plain, opposite the Bishop's Palace. In January 1834 Cotman was appointed Master of Landscape Drawing at King's College School in London, partly on the recommendation of Turner. Dante Gabriel Rossetti was one of his pupils.

ALEXANDER COZENS (1717–86)

Born in St Petersburg (where his father was a shipbuilder to Tsar Peter the Great), Cozens studied in the Rome studio of Claude-Joseph Vernet before being appointed drawing-master at Christ's Hospital and, in 1763, Eton College, a post which in turn led to his appointment to the royal household. An intellectual and ambitious artist who not only exhibited widely after 1760 but also sought to expound his theories of landscape painting in print, his extensive social contacts secured him an impressive list of subscribers – headed by King George III and many of his well-connected Eton pupils – for his *Principles of Beauty* of 1778.

JOSHUA CRISTALL (c.1767–1847)

Born in Cornwall but brought up in London, Joshua Cristall, although originally destined for the Cornish china clay trade, had by 1795 become a professional artist. He was not principally a landscape specialist, preferring

subject pictures, but in 1804 founder member of the Society of Painters in Watercolour (now the Royal Watercolour Society), and was the society's President in 1816, 1819 and from 1821 to 1831.

JOHN CROME (1768–1821)

Crome, painter and printmaker, was one of the stalwarts of the Norwich Society of Artists, and well acquainted with the more respectable patrons of that city. He worked as a drawing master in nearby Yarmouth throughout his career, and painted its estuary, harbour and beaches several times.

FRANCIS DANBY (1793–1861)

Born and raised in Ireland, of a wealthy family, Danby moved to Bristol in 1813, where he began painting watercolours. A further move to London in 1824 saw him abandon these in favour of poetical, Turneresque landscapes, which appear to have had some influence on the large, apocalyptic canvases of John Martin. Elected ARA in 1825, he was furious when he failed to become a full RA in 1829, and moved to Paris the following year. He only returned to London in 1838, after which he rebuilt his reputation for large, fantasy landscapes. In 1847, embittered at his apparent failure to win honours (and lucrative patronage), he retired to Exmouth in Devon to paint and build boats.

WILLIAM ALFRED DELAMOTTE (1775–1863)

Delamotte was born in Weymouth, where as a boy he was encouraged in his drawing by the town's royal patron, King George III. He enrolled in the Royal Academy Schools in 1793 and moved to Oxford, where he became a noted draughtsman. In 1803 he was appointed Drawing Master at the Royal Military Academy at Great Marlow, a post he was to occupy for many years. This employment gave him the freedom to paint for himself, and he exhibited regularly at the Royal Academy until 1850.

GEORGE GARRARD (1760–1826)

Garrard was chiefly an animal painter and sculptor. Having served an apprenticeship with Sawrey Gilpin, who

later became his father-in-law, Garrard joined the Royal Academy Schools as a student in 1781. Encouraged by his patron, the brewer and philanthropist Samuel Whitbread, he expanded into sculpture. Elected ARA in 1800, he is now best remembered for his portrait busts of quintessential Regency figures such as Benjamin West (of 1803) and Humphrey Repton (of 1810).

WILLIAM HENRY HUNT (1790–1864)
Like John Linnell, Hunt was apprenticed to John Varley in 1806, and joined him in Varley's oil-sketching expeditions at Twickenham. Hunt's subsequent career as a watercolourist was to lead him into a different branch of naturalism: his later studies of flowers, his still lifes and his popular paintings of birds' nests have a Pre-Raphaelite intensity of detail far removed from the impromptu feeling of this sketch. By the 1840s John Ruskin was an enthusiastic admirer.

WILLIAM GEORGE JENNINGS (1763–1854)
Jennings was a gentleman amateur who exhibited at the Royal Academy between 1797 and 1806 and at the Society of British Artists in 1830. From at least 1826 he was a friend of John Constable and, like Constable, he had a particular attachment to Hampstead Heath.

JAMES JOHNSON (1803–34)
Son of a publican, Bristol-born Johnson was an architectural draughtsman, watercolourist and painter who, finding it difficult to sell his work, tragically threw himself to his death out of a Bath window aged only thirty-one. His nearly fifty drawings and watercolours of Bristol are now highly prized.

THOMAS JONES (1742–1803)
Jones, born into a family of Welsh landowners, had been destined for the church, but the death of a relative released money to pay for his studies with Richard Wilson (1713–1782), whose studio he entered in 1763. He aspired to be a classical landscape painter in the manner of Wilson, but is chiefly remembered today for his original and striking oil sketches. Jones returned to England in

November 1783, after seven years in Italy. For the next six years he lived chiefly in London, accepting the fact that 'my professional Career was at an End, for excepting a few Commissions from three or four friends, whatever I have done in the walk of Art since, has been for my own Amusement.' In 1789 he inherited the family seat at Pencerrig, and retired there.

GEORGE ROBERT LEWIS (1782–1871)
Scion of a famously artistic family, Lewis studied with Henry Fuseli at the Royal Academy, and painted landscape only at the beginning of his career, becoming known later principally as a portrait painter after 1820.

JOHN LINNELL (1792–1882)
Linnell was the pupil and apprentice of the landscape painter John Varley, an influential teacher and central figure in the development of landscape painting in England in the early nineteenth century who also encouraged Linnell to join the Baptist Church. A friend and patron of both William Blake and Samuel Palmer (he introduced Blake to Palmer in 1824, and three years later Palmer married Linnell's daughter), he became increasingly eccentric in his later years, and fell out with Palmer, Constable and numerous members of the Royal Academy, to which he consistently failed to be elected. His increasing personal wealth meant that he could afford to retire to Redhill in 1851, where he painted religiously-inflected, visionary landscapes.

GEORGE STUBBS (1724–1806)
Liverpool-born Stubbs was the son of a leather merchant, and became the world's most famous painter of horses. He worked at his father's trade until the latter's death in 1741, after which he was briefly apprenticed to Lancashire painter Hamlet Winstanley. In the 1740s he worked as a portrait painter in the North of England and from c.1745 to 1751 he studied human anatomy at York County Hospital. In 1756 he rented a farmhouse in the village of Horkstow, Lincolnshire, and spent eighteen months dissecting horses, assisted by his common-law wife, Mary Spencer. He moved to London in c.1759, and in 1766

published his celebrated *The Anatomy of the Horse*. By this time his paintings of horses were in much demand, and from 1775 he regularly exhibited his works at the Royal Academy. Stubbs also painted historical pictures, and during the 1770s developed a new type of enamel painting for Wedgwood's ceramics.

FRANCIS TOWNE (1739–1816)

Towne is best known for his elegantly stylised watercolours, but began his artistic career as an apprentice to Thomas Brookshead, a London coach painter. He first went to Exeter in the 1760s, eventually establishing himself there as a drawing master and as a painter of country houses. He travelled to Rome in 1780, but his work never found favour in London and he remained essentially a Devon-based artist.

J.M.W. TURNER (1775–1851)

London-born Turner began drawing at the precocious age of eleven, and aged fourteen had a watercolour accepted for the Royal Academy's annual exhibition. In 1786 he moved from Brentford to Margate, a town he revisited many times in his life, and in 1789 stayed for a time with his uncle at Sunningwell, near Oxford. As a young man he worked for several architects, including James Wyatt and Thomas Hardwick, and studied under the topographical draughtsman Thomas Malton, whom Turner would later call 'my real master'. He entered the Royal Academy Schools in 1789, when he was fourteen years old, and was accepted as a full RA a year later, at the urging of Joshua Reynolds. Turner exhibited watercolours each year at the Academy, and exhibited his first oil painting, *Fishermen at Sea*, there in 1796. He travelled widely in Europe, and was a frequent guest of Lord Egremont at Petworth in Sussex. As Turner grew older, he became more eccentric, and engaged with a small but devoted circle of friends. His father, who lived with him for thirty years and worked as his studio assistant, died in 1829, which had a profound effect, and thereafter he was subject to bouts of depression. He never married but had a relationship with an older widow, Sarah Danby, and is believed to have been the father of her two daughters born in 1801 and 1811. At his request he was buried in St Paul's Cathedral, next to his early patron Sir Joshua Reynolds.

CORNELIUS VARLEY (1781–1873)

Brought up by his uncle Samuel, a watchmaker, Varley became increasingly interested in scientific instruments. Each summer Varley took a house at Twickenham by the river, and sent his students along the banks of the Thames on sketching excursions.

JAMES WARD (1769–1859)

The foremost animal painter of the day, Ward trained as an engraver before specialising in horse painters. Appointed by George IV to paint the royal bloodstock, he was then inexplicably dropped by the king, and remained penurious all of his life. Elected RA in 1811, he went into semi-retirement in 1830 and died a pauper, having been incapacitated by a stroke in 1855.

PETER DE WINT (1784–1849)

Staffordshire-born De Wint was the son of an English physician of Dutch extraction who had come to England from New York. Having trained with John Varley, between 1802 and 1808 De Wint was apprenticed to the portrait painter and mezzotint engraver John Raphael Smith. Smith would take him on fishing expeditions by the Thames, during which De Wint would sketch in oils. De Wint gained an early release from his apprenticeship on condition that he paint eighteen landscapes for Smith over two years. He first exhibited at the Royal Academy in 1807, and in 1812 became a member of the Society of Painters in Watercolours.

Index

Page numbers in **bold** type refer to biographical entries.